PUGET SOUND THROUGH AN ARTIST'S EYE

TONY ANGELL

WITH A FOREWORD BY IVAN DOIG

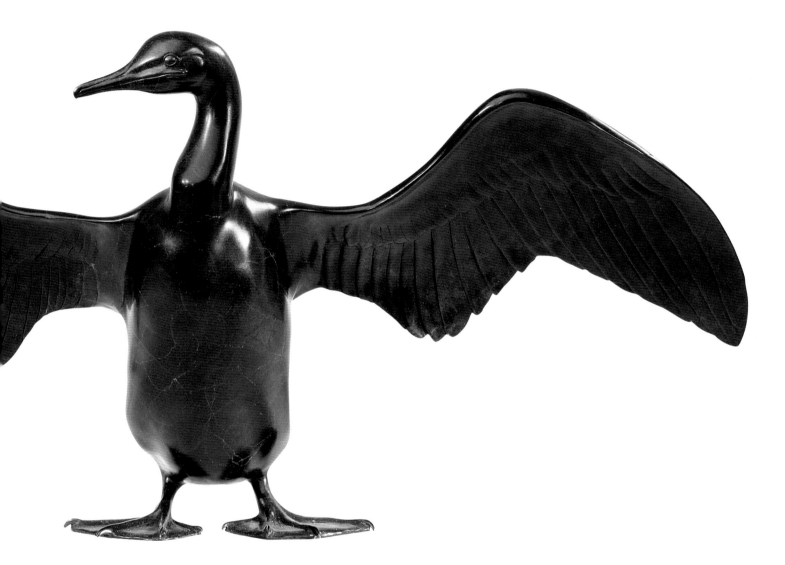

PUGET SOUND THROUGH AN ARTIST'S EYE

UNIVERSITY OF WASHINGTON PRESS SEATTLE AND LONDON

in association with

PEOPLE FOR PUGET SOUND SEATTLE

UNIVERSITY OF WASHINGTON PRESS
P.O. Box 50096, Seattle, WA 98145, U.S.A.
www.washington.edu/uwpress

PEOPLE FOR PUGET SOUND
911 Western Avenue, Suite 580
Seattle, WA 98104, U.S.A.
www.pugetsound.org

LIBRARY OF CONGRESS CATALOGING-IN-PUBLICATION DATA
Angell, Tony.
Puget Sound through an artist's eye / Tony Angell ;
with a foreword by Ivan Doig. — 1st ed.
p. cm.
Includes bibliographical references and index.
ISBN 978-0-295-98927-3 (cloth : alk. paper)
1. Angell, Tony. 2. Puget Sound Watershed (Wash.)—In art.
3. Art—Technique. I. Title.
N6537.A524A35 2009
704.9′437977—dc22 2009005464

The paper used in this publication is acid-free and 90 percent recycled from at least 50 percent post-consumer waste. It meets the minimum requirements of American National Standard for Information Sciences—Permanence of Paper for Printed Library Materials, ANSI Z39.48-1984.

PHOTO CREDITS
Photographs by Gregg Krogstad: ii-iii, x, xiv, 4, 5, 6, 7, 10, 13, 16, 18, 19, 20 (top), 21, 23 (top), 25, 27, 32, 35, 36, 39, 40, 42, 43, 44, 45, 51, 53, 56, 59 (bottom), 61, 68, 71, 72, 76, 79 (top), 85, 87, 89, 91, 93, 96, 100, 101, 102, 103, 108, 109, 119.
Photographs by Tony Angell: 2, 12, 14, 15, 17, 20 (bottom), 22, 23 (bottom), 24, 26, 29, 33, 41, 46, 50, 52, 58, 59 (top), 66, 74 (right), 78, 79 (bottom), 81, 82, 83, 84, 88, 90, 98, 99, 106, 107, 110, 111, 112, 115, 120.
Photographs by Mary Randlet: 57, 74 (left), 117.
Photographs by John Mooy: 64, 95.
Photograph by Lee Rolfe: 76-77.

JACKET PHOTO: *Racing Seabirds/Loons*, 1982. Marble, 15 × 30 × 12 in. (See page 87.)

END PAPERS: *Resting Seabirds*, 2005. Ink drawing, 20 × 46 in. A mixed company of gulls and terns gather to sunbathe where a low tide in late winter has exposed an islet of sand in Fisherman's Bay on Lopez Island.

FRONTISPIECE: *Totemic/Sunning Cormorant*, 1998. Bronze, 20 × 38 × 10 in.

v: *Cormorants at Sunset*, 1984. Ink drawing, 5 × 7 in.

vi: *Shore Ballet*, 1982. Ink drawing, 14 × 10 in. A nimble greater yellowlegs dances over sandy beaches and into shallow waters to catch its meal.

ix: *Young Harrier Pursuing Red-Wing*, 1985. Ink drawing, 15 × 12 in. (See page 28.)

x: *Bird Hunter*, 2004. Basalt, 13 × 15 × 4 in. Patient and acutely observant, a diminutive sharp-shinned hawk stands at the forest's edge. Consistently obdurate, basalt is an ideal stone for shaping this bird's delicate form.

xiv: *Nod's Owl*, 2005. Marble, 18 × 7 × 7 in. On the far reaches of the flood plain, abandoned farm buildings host roosting owls and remember the voices of those who first set plow into the deep soils here.

1: *Storm Petrels*, 1982. Ink drawing, 18 × 10 in. The pummeling of Pacific storms occasionally drives petrels into the outer Straits of Juan de Fuca, where they can be seen fluttering like dark moths over the water's surface.

8-9: *Migrants*, 1982. Ink drawing, 10 × 14 in. Common terns migrate to and through Puget Sound, bringing the winter's seascape to life with their raucous cries and precision flight.

62-63: *Descending Swans*, 2006. Ink drawing, 14 × 18 in. With Mount Baker as a witness, swans descend to the flood plains of the Sound.

126: *Ruddy Turnstones*, 1984. Ink drawing, 18 × 10 in. The presence of abundant and diverse flocks of shorebirds along Puget Sound shores is an indication of the region's vitality.

TO OUR CHILDREN, INTO WHOSE HANDS

THE STEWARDSHIP OF PUGET SOUND WILL PASS.

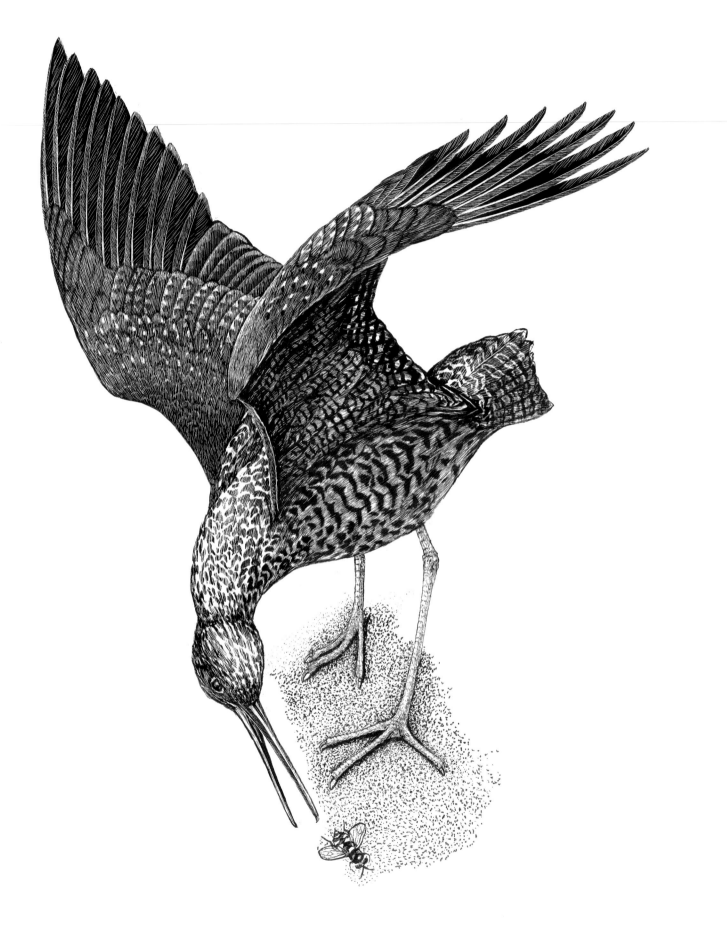

One of the little-understood responsibilities of the artist
is to bear witness—in almost a religious sense—to certain things.

—JOYCE CAROL OATES, *THE JOURNAL OF JOYCE CAROL OATES*

Let us give Nature a chance; she still knows her business better than we do.

—MONTAIGNE, *ESSAYS*

CONTENTS

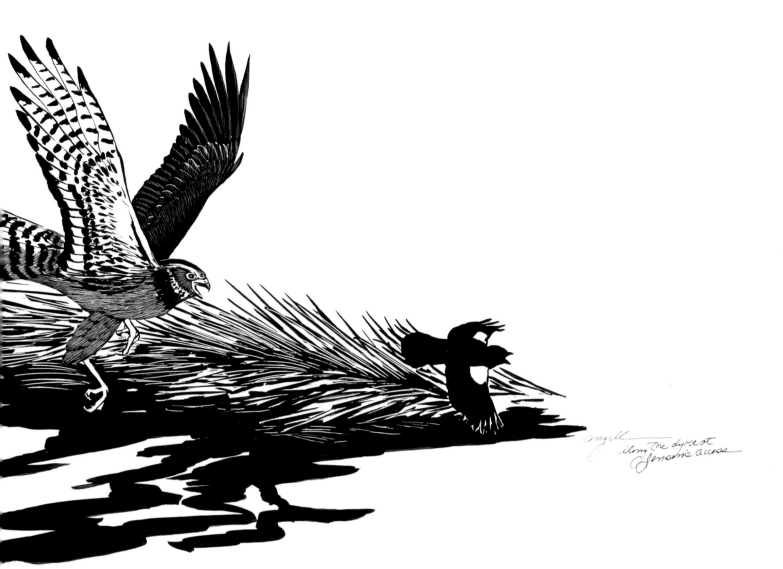

PART II

BRINGING EXPERIENCE AND INSPIRATION
INTO ARTISTIC EXPRESSION

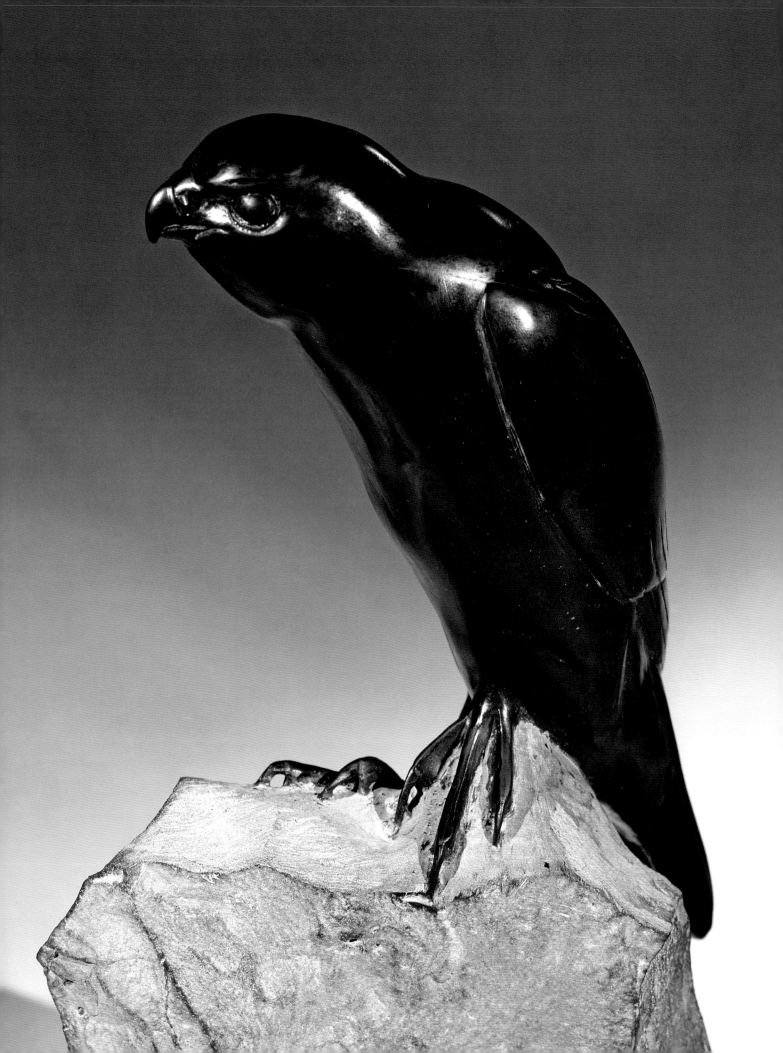

FOREWORD

Tony Angell's Stone Summonings: Art to Have and Hold

Messages from stone have firmed our lives for at least the last two hundred centuries. In the Lascaux Caves of southern France were discovered wall paintings done by our ancestors around 15,000 BC— "long-necked reindeer, majestic bulls, lowing cows, great horned bison," as the writer Guy Davenport described Lascaux's stone-held ancient nature art, "in files and herds, flowing in long strides down some run of time through the silence of the mountain's hollow." Think too of fossils. Of arrowheads. Feudal castles, medieval cathedrals. Petrified wood. The Great Wall of China. The Grand Canyon. The stone world's eloquence of what was, what lasts, what changes, is ever with us down our own run of time.

But when what is within stone has not quite yet made itself known—when it is still in native stone dialect, so to speak—we then need the interpreter, the sculptor.

"Each rock," Tony Angell has divulged to me as I have stood frozen stone-still myself on that damnably chilly floor of his outdoor studio watching him at work on some lopsided dusk-colored chunk, "has a particular spirit, a personality."

All throughout a day's sculpting (by now there have been forty years of such seeking out of signals within mute rock, and several hundred carvings) Tony strokes into the stone with a durable delicacy that constitutes a remarkable refinement of power and dimension.

The Angell way of working, of coaxing up out of that stone the raven or otter or owl wombed within there waiting to be brought to artistic life, relies on the sensing instruments that are his fingertips. At some instant known only to his tactile and kinetic capacities, he will suddenly dab a bit of spit to the rock and rub there to see how the color can be made to emerge. Some other moment, he may cup his hand and run it inquiringly across the texture of the stone to find the direction for his next chisel stroke.

Watching this is a bit like peeking at Merlin amid his recipes of alchemy,

or viewing Cellini at his table of tools. It is in fact a magic all of Tony's own: finding fire within rock. He and his legion of chisels and hammers and files and saws are engaged, in their daily way, in an act of profound combustion: the igniting of creation, the spark of art that flies upward out of our world's oldest, hardest fundaments.

Yet intuition always has a long ground of experience somewhere under it. In Tony's instance, his grasp of nature, *into* nature, derives from a most ancient and honorable root, the Latin verb *habere,* "to have, to hold." For see how it flowers into the trio of words vital to this immense artistic output:

Habitation, the ability to inhabit, with some part of himself, the lineage of living things beyond human as he captures their essence in his sculptures.

Habit, the long devotion of his muscles to the working hours needed to bring forth the exact ruffle of feather and fur from hardest material.

And not least, there is *habitat.* As much as this book is a summoning of an amazing number of sculpted beings, it is also a loving portrait of the Puget Sound country, the geographic heart of Tony's art. With his nailhead verbal dexterity, he gives us "a sculptural diary" of the landscapes and seascapes where the life-forms come to his artist's eye. Just a few of those encapsulated moments of meeting his images:

"Watching otter haul out on rocks and reefs off Lopez Island, I've come to feel that they share with us the pleasure of sunbathing."

"From the far north a modest tide of migratory shrikes flows into the Puget Sound lowlands to winter."

"In autumn the beach is a blend of grays and browns. Ahead of me as I walk along, a single plover bathes where fresh water has pooled from a recent rain."

Lovely stuff, and well over a hundred such introductions to his sculpted citizens of nature and "where their evolutionary path has taken them" await between these covers.

One last thing should be said, and I wish to say it as strongly as word and ink can express. There is deepness of soul on every page of this book, not simply nature's but of the Angell sort. A rare personality, capacious in every measure of this monumental man, reveals to us here that spiritual shape behind a great life's work. To encounter Tony and the plenteous generation of sculptures that have come to cold yet fiery life in that naturally refrigerated studio is literally to see a world in the making. Basically, he by now has populated a private planet—stone at its core, of course—with everlasting specimens that we at once recognize but

see in a new plane of being. He is bringing out essences of form and being in his true-to-life-yet-bigger-than-life sculpted creatures (in one of his matchless offhand summaries of everything, he once explained to me that each prodigious sculpture is merely the size the creature looks to him) that depend not on play of light but depth of source. His creations emanate in and of themselves, once the unnecessary penumbra of outer rock has been carved away.

And so we have, in the mighty circle of work that Tony Angell has bestowed on us across the past four decades, an orb of double importance. An everlasting sense of the Puget Sound country that is nature's blessedly varied kingdom, and within that a brilliantly preserved wingdom. The murrelet riding its black serpentine sheen; the constant raven under whose wisely wrought wings everything prospers: they tell us, they show us, the lastingness of beauty in nature's forms. They reflect to us, intrinsically, indelibly, forever, from this artist's eye.

IVAN DOIG

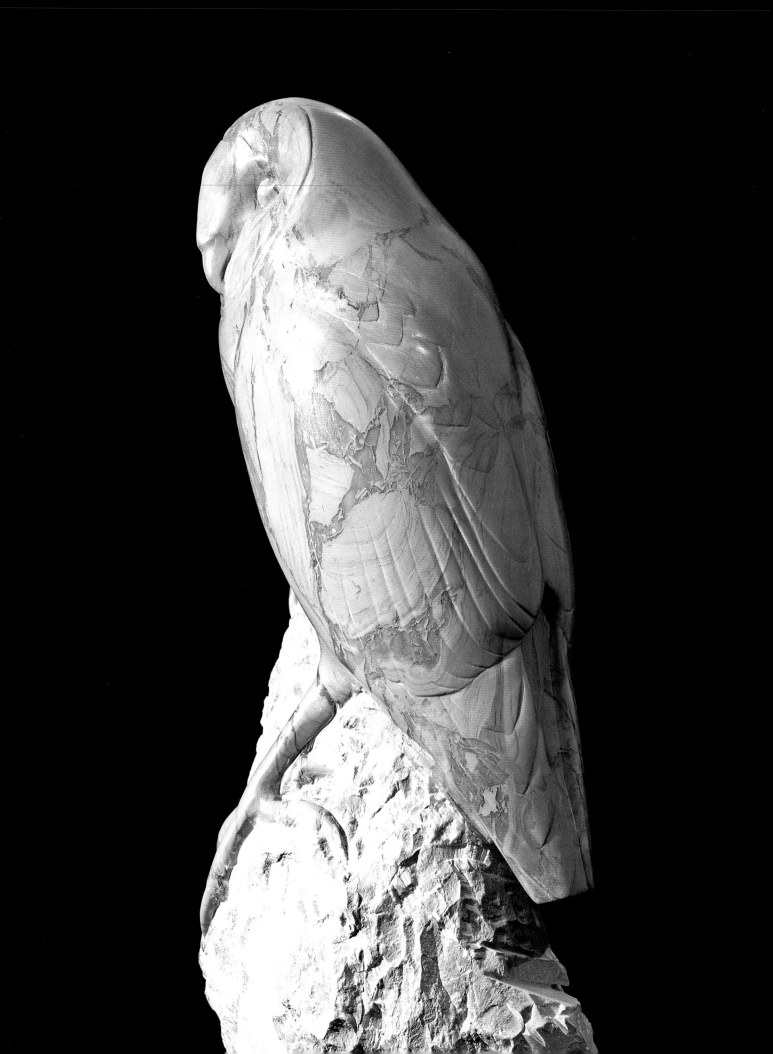

ACKNOWLEDGMENTS

Looking back over this body of work, I can think of many people who have shared their encouragement, wisdom, and insight that make such efforts possible. Dear artist friends Tom Jay, Jeff Day, Tom and Jeri Quinn, Gretchen Daiber and Mike Heath, Fen Lansdowne, Don Eckelberry, Marty Hill, and Les Perhacs, I've shared the field with you all, and our times together have been fundamental to inspiring and sustaining my creative energies. Ivan and Carol Doig, Paul and Anne Ehrlich, Bob and Dee Simmons, Bert Bender and Judith Darknall, and David Munsell have all set inspiring standards in their own work while bestowing upon me immeasurable gifts of encouragement through their friendships. And Harriet Bullitt, a special note of appreciation to you for publishing my first drawings in that earliest periodical related to nature in Puget Sound, *Pacific Search Magazine*. Much of what I have come to say artistically in the public forum began in those pages more than forty years ago.

I certainly doubt that I would have taken this path as seriously as I have had it not been for the constancy that characterized my mother's belief that my early artistic pursuits were important and fulfilling. She was an artist herself, and we exchanged ideas and shared images of our efforts until she was into her nineties. Also along those family lines, my uncle Nat Mooy gave great credit to my inquiries and creative work related to nature, even supplying me with my earliest wild specimens, which he would find along the roadside on his rural mail route, thereby giving me hands-on access to creatures as varied as timber rattlesnakes and horned owls. As my vision and appreciation of the natural history of Puget Sound expanded, it was Frank Richardson of the Burke Museum who kindly opened up the resources of that facility for my use.

I want to thank the distinguished writer Bill Dietrich and the outstanding *Seattle Times* environmental reporter Lynda Mapes for their time and generous sharing of the current biological and statistical information on Puget Sound that made my concluding thoughts on our region more up-to-date and accurate.

In the matters of bringing this book from possibility to fulfillment, I am very grateful to University of Washington Press director Pat Soden. His encourage-

ment brought my focus around to sharing that part of my work that has been so strongly influenced by my life here in the Puget Sound basin. In company with Kathy Fletcher and Mike Sato of People For Puget Sound, the Press provided the momentum and resources required to organize and produce what we now have in hand.

Over the time I spent writing and organizing the book's content, my family has been a constant source of support. My wife Lee Rolfe and daughters Gavia, Larka, Gilia, and Bryony over many years have tolerated and helped clean up the messes I claimed were part of the creative process, patiently encouraged me through the sticking points, and shared the joy of being in the field of wild nature that makes our lives so fulfilling. A man could not be more blessed.

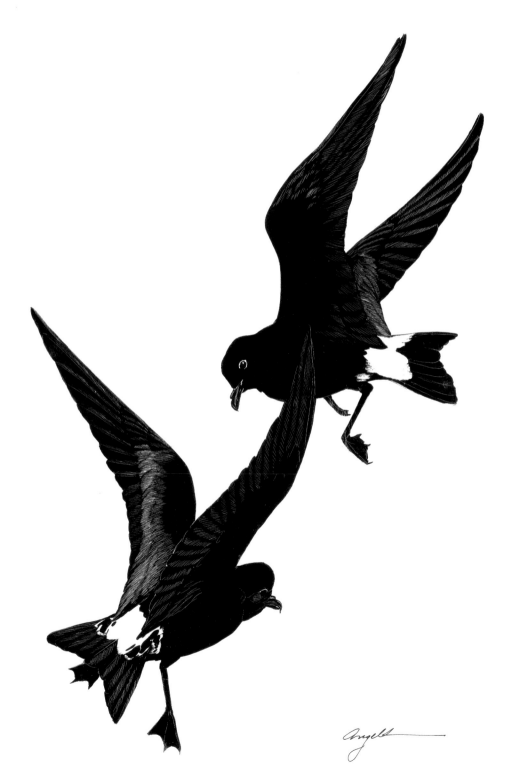

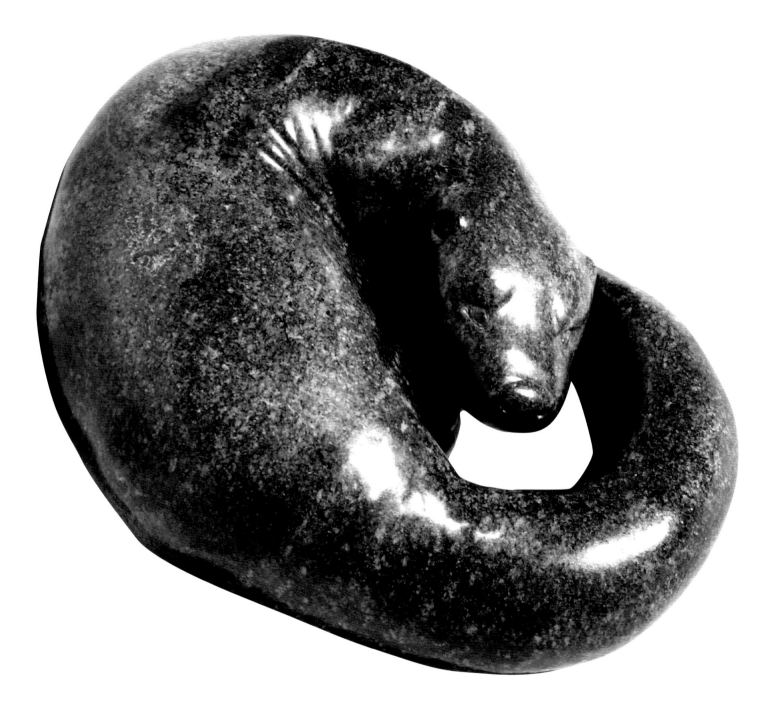

Otter on Watch, 1998
Serpentinite, 8 × 16 × 16 in.
An otter takes my measure as I swim by the reef where it suns.

INTRODUCTION

It is late summer and I'm looking southwestward from a bluff below Chadwick Hill on Lopez Island. The view across the Strait of Juan de Fuca holds little evidence suggesting the presence of the four-plus million people living within the Puget Sound basin. Then a tanker churns into view from behind a headland, and I'm brought back from the Age of Exploration to the twenty-first century. So powerful do the profiles of nature remain here that it's easy to imagine that there are no challenges to the pristine integrity of Puget Sound.

From the beach below, that evocative perfume of the sea, decaying kelp, is wafted up on the breeze as I watch a line of pelagic cormorants fly with impressive certainty across the mouth of the bay. Near the shore, disputing kingfishers rattle in their mercenary manner, chasing one another through the madronas. Behind me, in the woods, a Cooper's hawk chants and ravens chortle and croak, composing poems and telling jokes. For the moment, at least, all is right with the world.

More than a place to live, Puget Sound is a dear friend. It possesses a personality composed of its natural history, a range of moods, and infinite messages that inform, influence, and inspire. A constant in a chaotic world, its beauty is riveting and an endless source of ideas and possibilities for artistic exploration. Its raw edges of land and seascape have, over the course of my lifetime, heightened and refined my senses. My drawings and carvings, based on my experiences here, have become a means of reconciling myself with nature.

It is easiest to describe this place by its impressive scale. The inland sea portion of our greater Puget Sound is composed of twenty-eight hundred square miles of saltwater, and into this colossal embayment flow twelve major rivers and perhaps another ten thousand rivulets. The greater Puget Sound basin itself includes nineteen major watersheds and covers sixteen thousand square miles, an area that measured in a straight line would wrap two-thirds of the way around the earth. As an artist, however, I've come to look at this region differently. I see, of course, discrete parts, including forests, river valleys, shores, and waterways, but these interdependent elements are best considered when seen as the composites of the larger living system that is Puget Sound. That I have

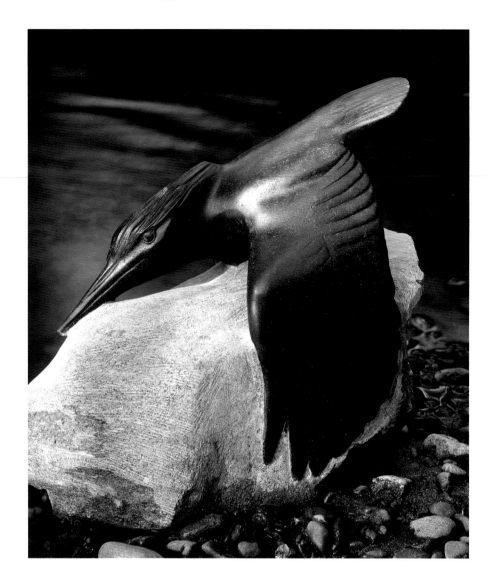

Over Water/Kingfisher, 1983
Chlorite, 7 × 12 × 8 in.
Kingfishers can fly forty miles an hour, skimming the water's surface, to chase one another, beak to tail, before swinging up into an overhanging tree to resume their vigil for surfacing fish. For all of its virtues, stone has its limits to the degree to which one can extend a form. This work required the bird to be supported by stone from beneath in such a manner that the momentum of the kingfisher's flight would not be lost.

found life here that inspires my artistic inclinations is the result of all the parts that remain healthy and vital.

It is my purpose here to share that part of my work that is distinctly developed from my experiences here in Puget Sound. My hope and expectation is that, where words fail, art will prevail, and that my work will invite interest and inquiry. *Interest* in the forms that evolution has fashioned to emerge as the diversity of life within this unique region, and *inquiry* as to how these life forms might intersect with and influence our own lives.

The first part of this book is therefore organized around the Puget Sound

basin. Each chapter includes a general narrative describing an ecosystem, while the artwork provides an aesthetic image of a few of the important life forms residing there.

The second part of the book, while still emphasizing the beauty of our wild cohorts here in Puget Sound, gives some background on me and my work, including some of the processes necessary to produce a stone carving. This section also has a chapter describing a few of the conclusions I've drawn on the condition of our natural heritage here in Puget Sound. It's been more than twenty-five years since I wrote and illustrated *Marine Birds and Mammals of Puget Sound* with Ken Balcomb. A lot has changed, and, although it is not the sole purpose of this book to do so, it would be irresponsible of me not to make note of and reflect upon this. In an appendix I've included an annotated list of a few of the books that combine art and narrative with a historical and contempo-

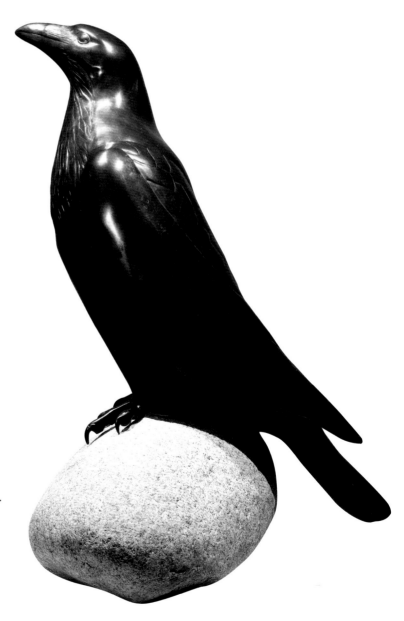

Raven Composing a Poem, 2001
Bronze, 48 × 12 × 18 in.
It's a cloudless summer day as I listen to ravens behind me in the woods. There's an endless repertoire of croaks, krawks, barks, yelps, and yodels. Other ravens across the bay respond in kind, and I imagine that this is a day of poetry and perhaps a few jokes shared between clans of these birds.

rary poignancy to remind us of what we derive from our contact with nature. I also describe a few of the guide books that give information on points of public access to the region's watersheds and shorelines where our natural diversity may be witnessed.

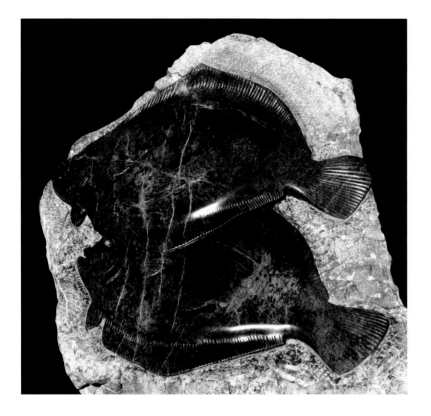

Flounders Off Ft. Flagler, 1985
Serpentine, 3 × 15 × 19 in.
Starry flounders are etched in the colors of the bottom of the bay off Ft. Flagler State Park. The patterns in the stone suggest the green filtered light playing off their flat surfaces.

Shadow Form/Black Skate, 1998
Black marble, 5 × 28 × 16 in.
The perimeter road along the edge of Fisherman's Bay on Lopez Island affords a sweeping view of enclosed waters. As my daughter Larka and I were taking this route into the village one afternoon, a series of splashes caught my eye. A black skate glided steadily beneath the bluff, its five-foot span of wings propelling it along as it seined the bay's water for invertebrates.

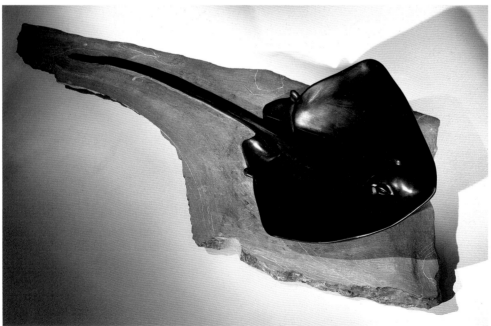

Astending Eagles (model for monument), 1982
Bronze, 18 × 7 × 9 in.

Eagle flight is riveting. At times gravity seems to be defied. The sculptural challenge is to suggest this freedom and, if possible, convey the feel of the thermal-charged day that holds the birds aloft. Bald eagles will remain in numbers on Puget Sound only as long as we sustain the salt- and freshwater fisheries upon which they rely.

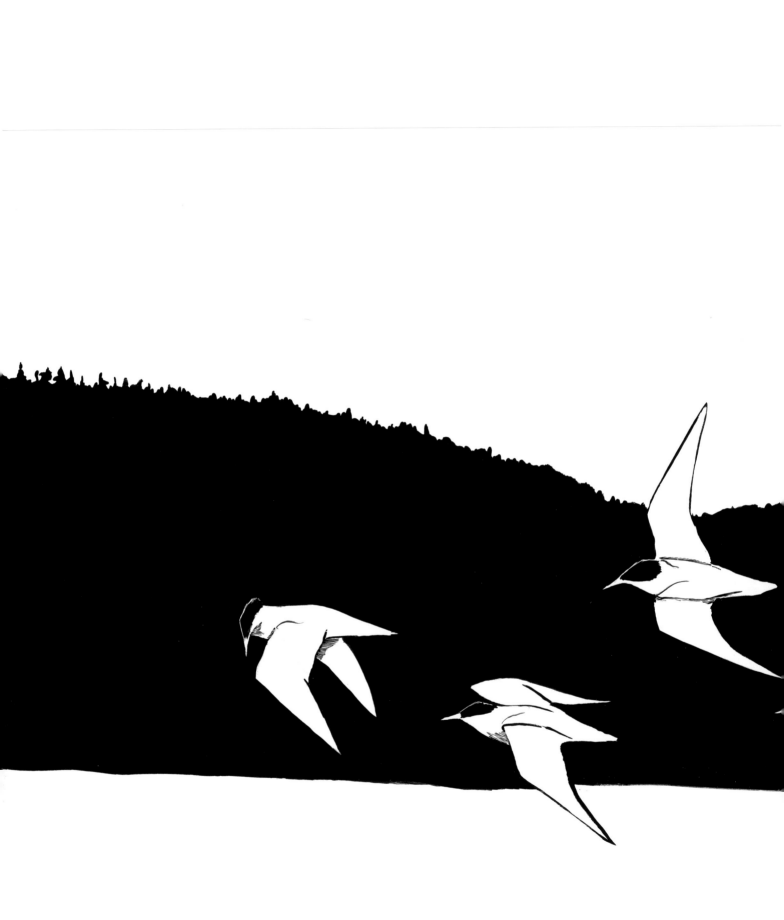

THE NATURAL DIVERSITY OF PUGET SOUND AS THE ARTIST'S PALETTE

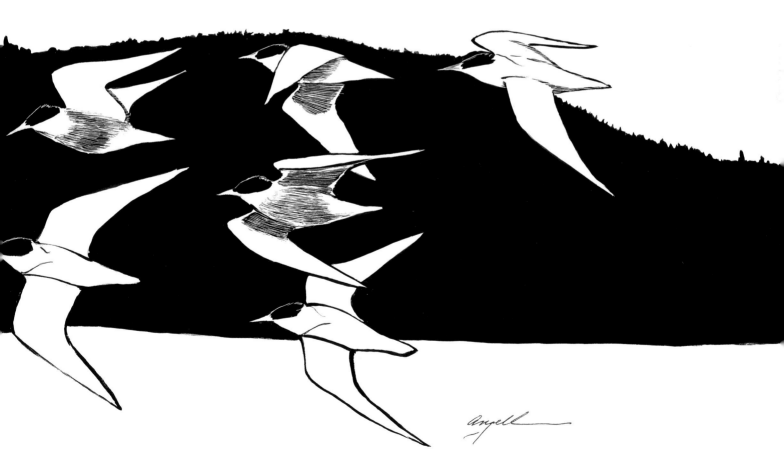

Sentinels, 2000
Bronze, 12 × 7 × 12 in.
Steller's jays are bold and inquisitive,
not unlike the explorer-scientist George
Wilhelm Steller for whom they were
named. If I'm hunkered down in the
woods on the mainland for any length
of time, one or more of these jays usually
finds me and, after sizing me up, lets all
the woodland know of my whereabouts.

THE HIGH COUNTRY AND RIVER VALLEYS

I believe in the forest, and in the meadow. . . . Life consists with wildness. The most alive is the wildest. Not yet subdued to man, its presence refreshes him.

—THOREAU, "WALKING"

The panoramic view facing south from atop Mount Constitution on Orcas Island conveys the expanse of the complex system that is greater Puget Sound. From east to west, the entire region appears cradled between the Cascades and Olympics, with Mount Rainier looming up between the ranges as the southern terminus of the Sound. Between the mountain flanks are the valleys fashioned by the forces of glaciers and the rivers flowing to this inland sea. Along the shore margins of the adjacent islands and the mainland are mudflats, beaches of sand and cobble, bluffs, spits, and rocky headlands that sustain a diversity of life and productivity that give character to our region, which historically has been as biologically rich as any place on earth. From my viewpoint, I can imagine a single living fabric stretched over our region's rocky back and held together by the weft of water and the warp of soils. Composed of varied and immeasurable living parts, it's a functioning body, with each element interacting with and affecting the others.

Along alpine ridges of our mountain ranges much of the first flow of fresh water to the Sound begins. Rivulets of melted snow converge to become creeks and streams that in turn feed our great rivers coursing like arteries through forests of hemlock, fir, and cedar. Thoroughfares for aquatic species, these waterways continually transport nutrients that sustain communities of life in the forests, valleys, estuaries, and marine waters.

To a great degree the richness and character of our natural history here is defined by these upland forests, and the services they provide for us are innumerable. Healthy tree stands moderate our weather and buffer the land from the onslaught of storms. The forest canopy "breathes" oxygen into our atmosphere as it also absorbs CO_2 and combs pollutants from the air. The well-rooted trees

Sunning Hawk, 1986

Slate, 6 × 11 × 12 in.

Somewhere in our forests a hawk is pausing from its hunting life to stretch and sun.

Mountain Gnome/Pygmy Owl, 1985
Slate, 10 × 5 × 3.5 in.
Birds of the higher slopes of our Western Cascades,
these diminutive owls descend the slopes to winter in
the river valleys of Puget Sound. Seen from a distance
atop snags in daylight, they look more like rotund,
stub-tailed fox sparrows than hunting owls.

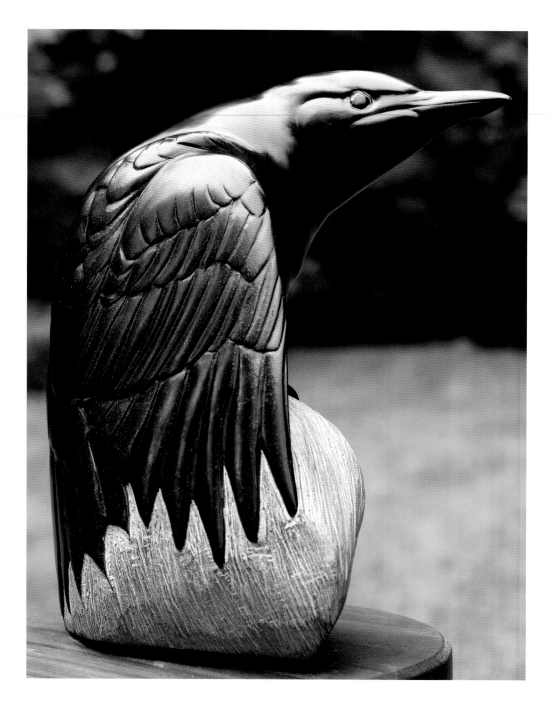

Flicker, 1985

Chlorite, 10 × 5 × 6 in.

The ubiquitous flicker is an essential player in sustaining the diversity of life in Puget Sound. It digs cavities that are later employed as nests and retreats for waterfowl, owls, small mammals, and beneficial insects. Flickers chisel, chip, and probe for those insects that might otherwise overwhelm our stands of fir, cedar, and hemlock. I have polished this stone to a black luster that emphasizes the powerful design of the bird.

hold moisture beneath a dense ground cover of ferns, Oregon grape, and salal. Hillsides are kept intact by this living overlay, which allows water from intense rains to slowly percolate through the soils. The runoff from a heavy snow pack and an early spring deluge is naturally regulated and drains slowly into creeks and streams. Such steady filtered flows maintain both the quality and the level of the water so essential to the vitality of our fisheries.

In our coastal forests, from below ground to the treetops, life is abundant and diverse. Resident all year, bears and lions prowl the ridges and river shorelines as Steller's jays scold and pine martins and fishers chase Douglas squirrels through the thick canopy. Spring woods reverberate with the drumming of ruffed grouse and the hammering of flickers and pileated woodpeckers, with a background of melodious song from tanagers and warblers. Ponds, bogs, and lakes, cupped amid the tree stands, provide retreats for breeding waterfowl and the more subtle aquatic species of frog and salamander.

Where our remaining ancient forest still stands trees are growing that were hundreds of years old when Captain George Vancouver named a portion of this

Pond Turtle, 1995
Marble, 5 × 5 × 6 in.
What we don't see we often fail to acknowledge or assume isn't there. So much of our fresh- and saltwater life has been threatened before we have been able to witness its dilemma, appreciate its beauty, or know its essential role in the vitality of a natural system. So it is with turtles. They go about their way in shells elegantly sculpted, with a manner so purposeful you feel it must be based on a decision reached over a million years of deliberation.

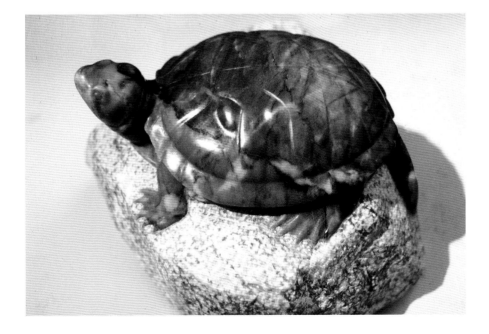

Inquisitive Owl, 1998
Alabaster, 16 × 7 × 10 in.
When young owls fledge into the world beyond their nest, it's easy for me to compare their behavior with that of a carefree and inquisitive child who is fascinated with every new thing coming within reach. The mottled gray in this stone seemed a match for the down-dusted plumage of a young spotted owl just fledged from the nest.

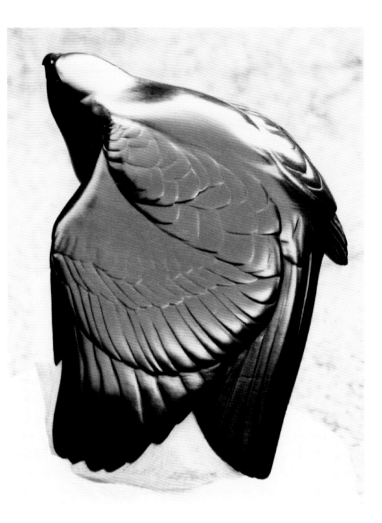

Wing Stretch, 1981
Chlorite, 12 × 7 × 9 in.
The hawk opens its wing, and layer
after layer of finely defined feathers
are revealed.

region for Peter Puget, a member of his crew that explored here in 1798. Among
this rare old growth of Douglas fir and cedar are species whose lives are exclu-
sively linked to this wilderness. The rare northern goshawk and the endangered
spotted owl and marbled murrelet have evolved over hundreds of thousands
of years to fit their habits, forms, and colors to the scale and complexity of our
forest wilderness.

Some time ago, while wandering through the old growth bordering the
Duckabush River, an acquaintance made a remarkable discovery. In a shallow
eddy, out of the river's main current, he found the body of an adult goshawk
floating face down in the water. When retrieved, the bird's plumage was sod-
den but in otherwise perfect condition. The hawk's body provided no clues as to
what might have led to its death.

As good fortune would have it, my friend was kind enough to let me have the
bird. Once it thawed I could articulate the goshawk's wings and feet to feel the
fullness of its muscled upper body and better appreciate how these forest hawks
are put together. Wishing to preserve the immaculate plumage, I skinned the

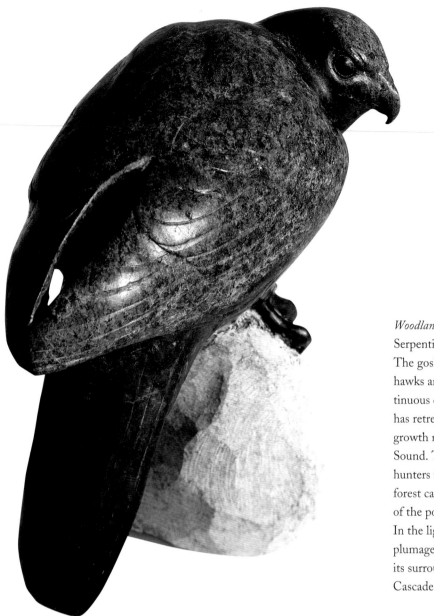

Woodland Hunter, 2005
Serpentinite, 14 × 8 × 14 in.
The goshawk is the largest of our forest hawks and the most threatened by the continuous cutting of ancient forest stands. It has retreated into the few fragments of old growth remaining in the watersheds of Puget Sound. To see one of these long-bodied hunters thread through openings below the forest canopy at high speed defies our sense of the possible, so quick does it maneuver. In the light-dappled deep forest, the bird's plumage takes up the color and patterns of its surroundings, and a stone found in the Cascades seemed a perfect match.

hawk and during the process found that its crop was full to the point of bursting. To my great surprise, I found the upper half of a Douglas squirrel compacted there. Even more surprising was that the other half of the full-grown mammal was in the hawk's stomach. A close look at the meal suggested the hawk had done little more than bite the squirrel in half before bolting down both portions. I wondered if the bird's death was somehow related to this last meal. Had it been challenged by another hawk for the squirrel and had it in desperation sought to swallow the catch almost entire, which caused it to choke to death? Had a fight ensued in which the hawk was driven into the river to drown? I could only speculate.

Where old-growth conditions prevail, nurseries of Pacific salmon and steelhead are intact. Since our last period of glaciation six thousand years ago, a vital

Forest Salamander, 2001
Serpentine, 5 × 4 × 8 in.
Moving at a measured pace and cryptically colored, salamanders are easy to overlook.
We now know that these species are among the most vulnerable to environmental
changes, and worldwide nearly a third of their kind are threatened by extinction.
When we do see them, they are as a fragment of green light, moving slowly over
the dark cushion of the rain forest floor.

The Cycle, 1995
Bronze, 4 × 14 × 6 in.
Since humankind has been in Puget Sound, the salmon has been fundamental to our economic and ecological welfare, and as such remains an integral part of our cultural rituals. Even in death this icon conveys a message of renewal, life, and sustainability, as the nutrients of the decaying fish will eventually nourish life in the forest in general and the forthcoming hatch of young salmon in particular.

Young Eagle (detail of head), 1979
Chlorite, 17 × 12 × 20 in.
A mile high, a pair of eagles soar on thermals rising from the heated cliffs above the upper Skagit. One bird cuts from cloud level to descend to the river's edge, where it has spotted a salmon carcass. What views of the earth eagles must have with vision several times more powerful than ours! The faded and fuzzy forms we see in the distance are sharply defined, life-maintaining information in the eagle's eyes. Along the upper Skagit in the late fall and winter, concentrations of bald eagles feeding on spawned-out salmon are among the largest on the continent.

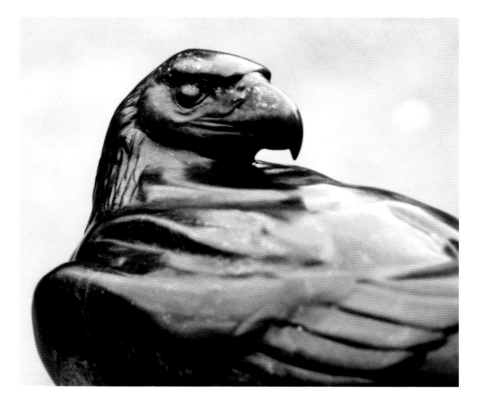

Snow Geese at Jensen's Access, 1982
Alabaster, 6 × 20 × 15 in.
Great flocks of snow geese wintering along northern Puget Sound suggest the abundance of wildlife that once occupied the region. Like vast patches of snow, geese cover the mud-gray fields of the Skagit and Stillaguamish deltas. I've tried to suggest the lifelong pair bonding of this species, whose numbers have increased because of the agriculture along the floodplain.

relationship has evolved between fish and forest. When the spawned-out adult fish are pulled from the water and into the woods to be eaten by foraging bears, coyotes, and eagles, their remains, digested or otherwise, are scattered over the forest floor. Detritivores break down the remnants further, and the nutrients seep into the soil, enabling the great trees to take them up and thrive. The forest has kept the flow of water pure and constant to sustain the fish, and the fish in turn have nurtured the forest. Our Pacific salmon and stands of old growth have a silent pact of reciprocity.

Over millennia the rivers of Puget Sound have deposited along their courses soils that are of exceptional depth and richness. Agriculture has flourished, and in the open and fallow fields along the lower Nisqually, Stillaguamish, Skagit, Samish, and Nooksack rivers, waterfowl still come each fall by the thousands to be sustained here through the winter. In the fields and along the edges of the

Mink with Catch, 1981
Chlorite, 24 × 15 × 12 in.
While not in the otter's league
when it comes to capturing fish,
mink are capable and determined
as they fish the shallows and tide
pools of Puget Sound.

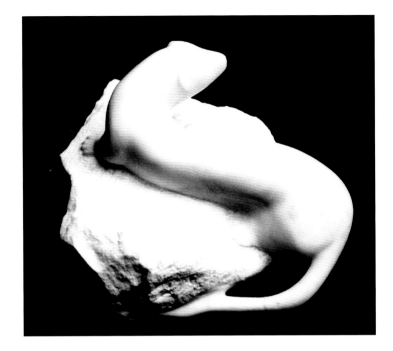

Ermine, 1991
Marble, 5 × 12 × 6 in.
The cream-colored marble is an ideal match for the hunting weasel's winter coat.

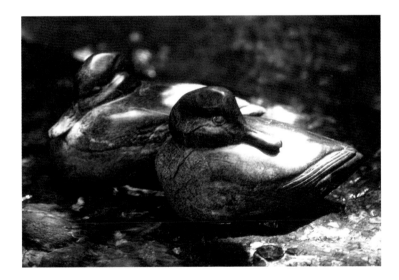

Greenwings, 1973
Serpentine, 5 × 10 × 10 in.
In the fall and winter along the rural reaches of the Sound, teals join mallards, shovelers, gadwalls, wigeons, buffleheads, and pintails to feed in the freshwater ponds and sloughs that form behind the dykes protecting the farmland from incoming tides. The deep greens of the stone match the verdant surroundings of early spring and the flash of color in a teal's wings.

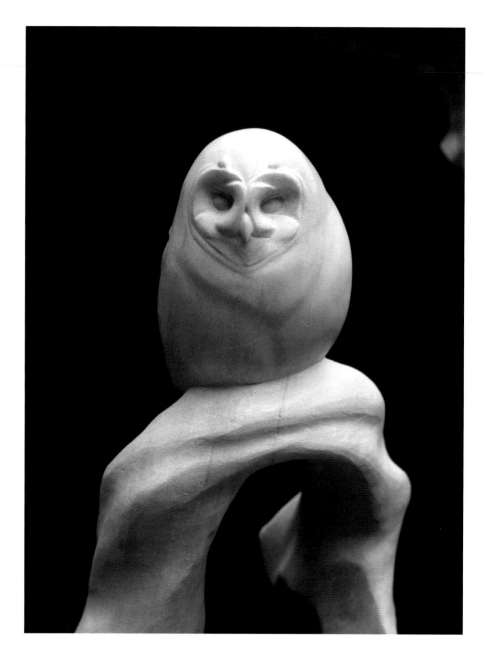

Marsh Owl, 1995
Limestone, 28 × 14 × 14 in.
Like the harrier, the short-eared owl is a hallmark of our salt marshes. Active in daylight, these owls chase one another to squabble over hunting territories and are themselves pursued by hawks that seek to pirate their catches. So cryptic is their pattern and color that they are nearly invisible when perched low on battered beach logs, scouting for scurrying prey in the grasses below them.

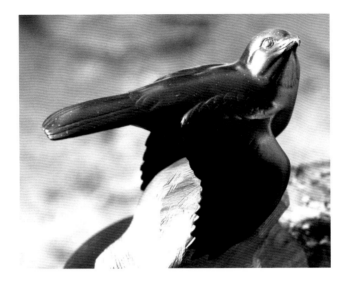

Northern Shrike, 1984

Chlorite, 7 × 5 × 10 in.

From the far north a modest tide of migratory shrikes flows into the Puget Sound lowlands to winter. They are particularly alert to the presence of hawks and falcons, and raptor trappers historically kept captive shrikes nearby to alert them to the approach of a bird of prey. Once, while my daughter Gavia and I were bike riding, a shrike flew directly toward us to seize a meadow vole at our feet. While the prey had been invisible to us, the sharp-eyed bird had spotted it when we had disturbed it on the path we were following. This predatory songbird the size of a robin transferred the vole from its beak to its feet and flew off to a stand of wild rose, where it fastened its meal to a thick thorn for feeding.

waterways, keeping company with the geese, swans, and ducks, are shorebirds that forage in even greater numbers. Eagles scouting for prey can stir a flock of ten thousand geese into a clamorous frenzy. Like a monstrous white wave rising from the dark earth, the birds become a single body that stretches out, turns back into itself, and ultimately collapses onto an open field like a spent blizzard.

Deer mice, voles, moles, and shrews feed on grasses, seeds, and insects from the fields and along the dykes that separate these lowlands from the river's flood and the surge of the Sound's high tides. In company with small passerines, these little mammals are part of a feeding foundation for a population of larger predators. Long-tailed weasel and mink, hot on the scent of a meal, search patches of grass for prey and snake through piles of drift logs.

Harriers course back and forth throughout the year, hunting along the edges of the duck-filled ponds, sloughs, and borders of the roadways and dykes. Out and about in the daylight, short-eared and snowy owls winter here, along with rough-legged and red-tailed hawks. There have been mornings when, from a

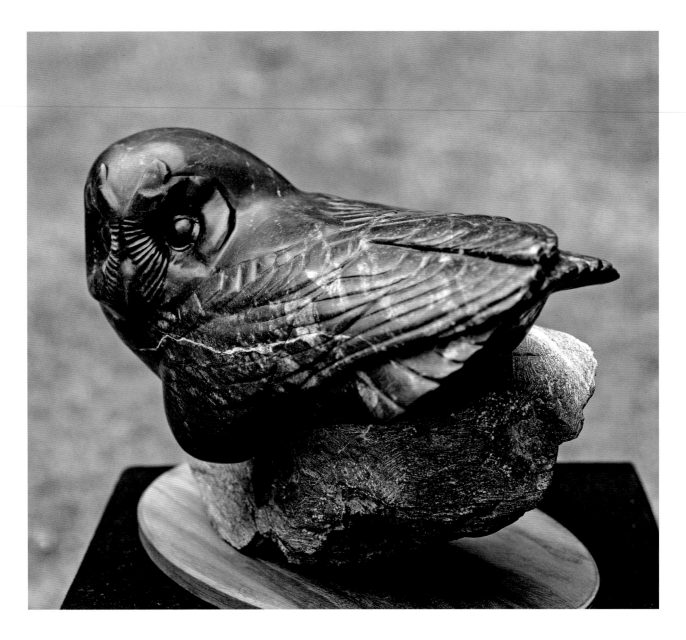

Marsh Owl, 1981
Serpentine, 6 × 12 × 6 in.
The colors and shape of a piece of serpentine combine with my imagination, and the carving begins. While the stone shape has already suggested what's within, there's also an exploration going on, and as I carve I seek to incorporate surprises in pattern and color that turn up, as they often take me to an idea larger than what I began with. The owls themselves have plumage washed in browns and grays, but the material echoed the shadows and moods of salt marshes and fields in early spring, where the owls hunt. The owl's attitude, alert and inquisitive, was revealed to me over the many months I once cared for an injured short-eared owl.

In Pursuit/At the Estuary, 2002

Bronze, 14 × 16 × 5 in.

Over Samish Bay, small flocks of plovers are herded into hurried configurations by a pair of chasing falcons. In larger numbers they are even more extraordinary. In an instant, a cloud of a thousand birds, strung out as a dark thread of beating wings against a gray horizon, bursts into an array of light as the flock condenses, turns, and brings the birds' bright breasts into view.

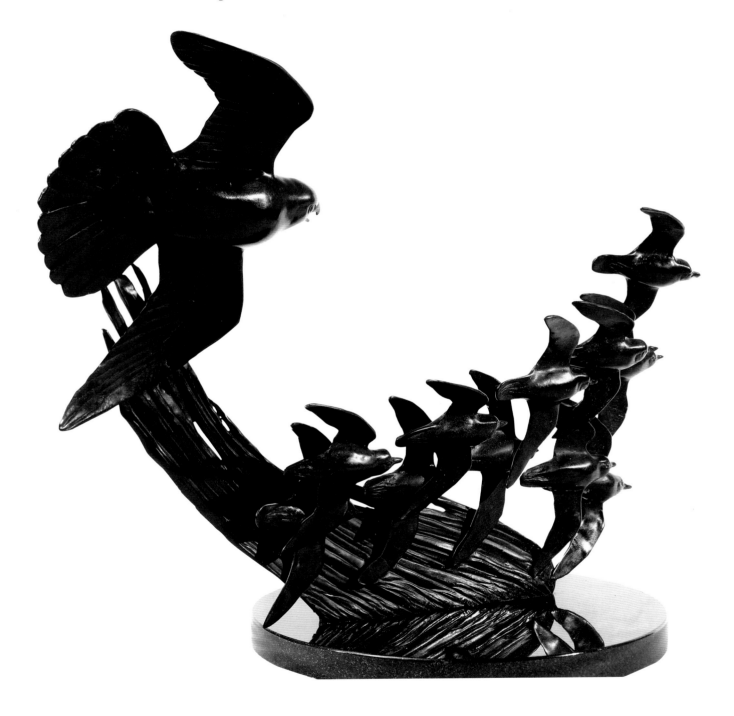

single vantage point, I've seen them all perched patiently over the landscape at different elevations, watching intently for some faint sign that will launch them into determined hunting flight. Over mudflats and fields, stirring up clouds of sandpipers and plovers, are merlins, peregrines, and, on rare occasions, gyrfalcons. Relentless in pursuit, these falcons pitch into flocks of shorebirds like the snapping ends of whips.

Young Harrier Pursuing Red-Wing, 1985
Ink drawing, 15 × 12 in.
A young harrier cuts from its usual hunting course to pursue an adult red-winged blackbird. The hawk's chase ends in failure, as the red-wing knows all the escape routes in the cattail marsh.

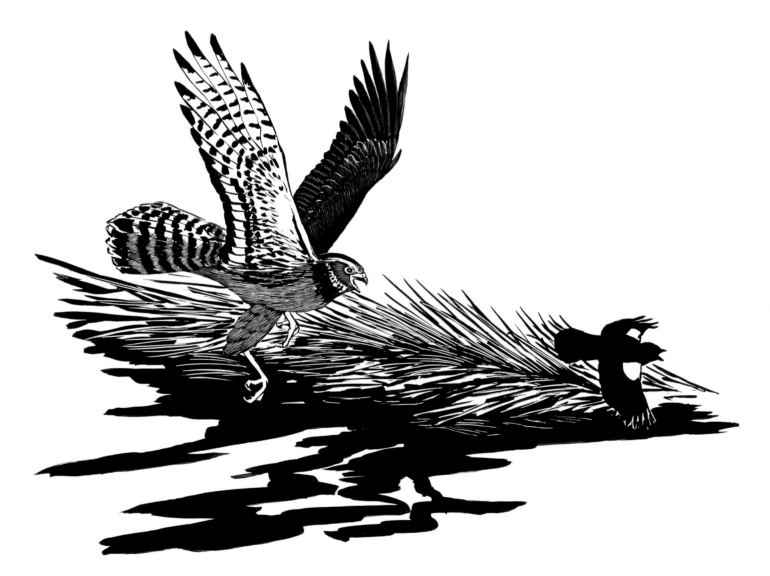

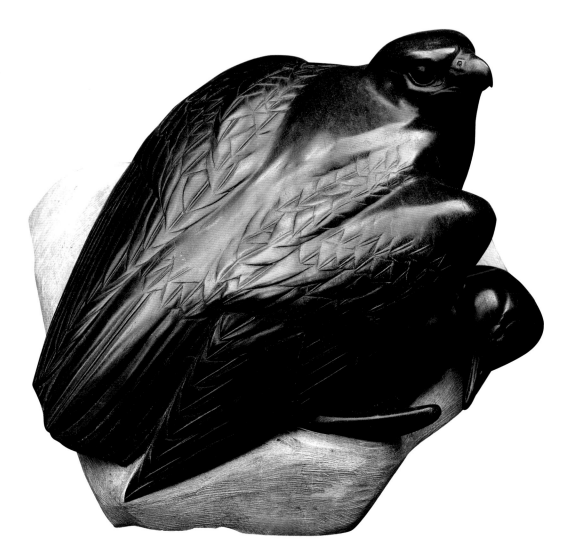

Falcon over Teal, 1980
Chlorite, 6 × 15 × 14 in.
Hunting along the salt marshes,
a falcon must be alert to the possibil-
ity that other predatory birds might try
to steal its catch. Along the Nooksack
estuary I once watched a pair of harriers
succeed in driving a falcon from a duck
it had just taken down at the edge of a
marsh. For a moment the falcon sought
to shield its prey from view with its wing.
The gesture, while futile, was neverthe-
less compelling to me as a sculptural
design.

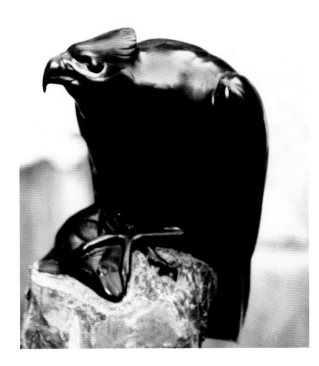

Osprey, 1990
Black marble, 30 × 10 × 12 in.
Lanky-legged and long-taloned, ospreys
fish from our bays, lakes, and rivers.

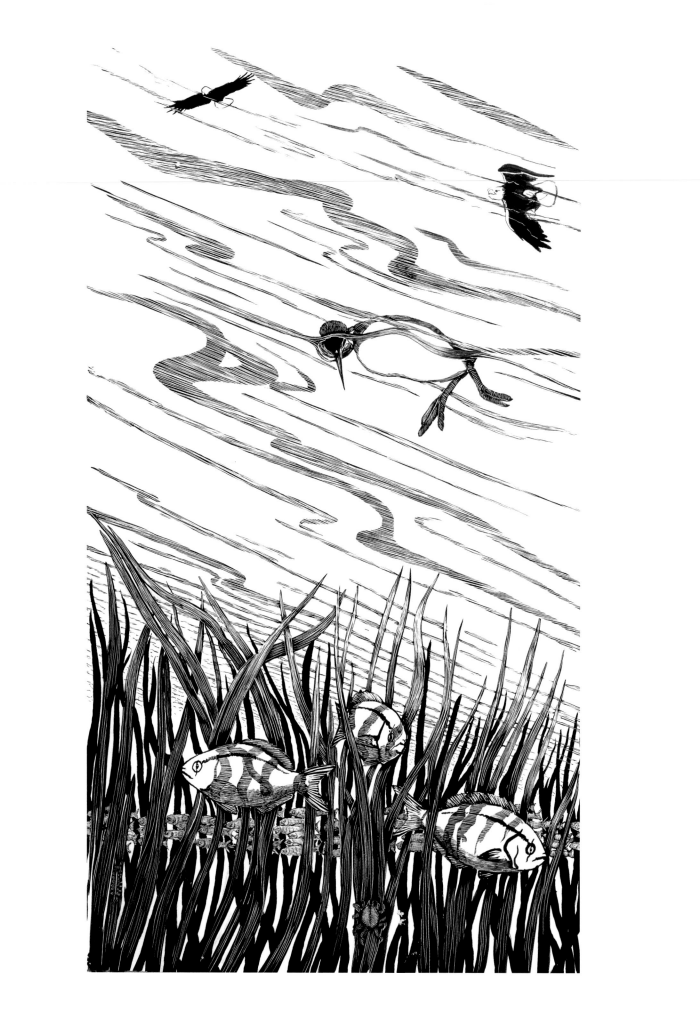

WHERE THE GREAT RIVERS MEET THE SOUND

Vision is the art of seeing things invisible.

—JONATHAN SWIFT, "THOUGHTS ON VARIOUS SUBJECTS"

When I make a journey north from Olympia to Bellingham on Interstate 5, I cross the Nisqually, Puyallup, Duwamish, Snohomish, Stillaguamish, Skagit, Samish, and Nooksack. These are the big rivers along the Sound's eastern perimeter. To the west, pouring their fresh waters into Hood Canal, Puget Sound, and the Strait of Juan de Fuca, are other rivers with native names: Skokomish, Duckabush, Dosewallips, Quilcene, Dungeness, Elwah, Pysht, Clallam, Hoko, and Sikiu. Where these nutrient-rich rivers mix with the Sound's waters, estuaries are formed. In fact, one could argue that all of the Sound is an estuary. And where coastal wetlands remain and toxins are absent, miracles of biological production are performed.

Just as our region's forests, lakes, and rivers provide habitat indispensable for us and for wildlife, meadows of eelgrass, growing at or near the mouths of rivers, sustain an exceptionally important community of life. Amid the density of grass blades are nurseries for the herring and smelt that are critical links in our marine food chain. Here, too, young salmon, fresh from their natal sites, find food and safety as they prepare for their years at sea. On the waters of the

Fishing Western Grebe over Eelgrass, 2007
Ink drawing, 14 × 10 in.
The eelgrass bed of the near shore is the foundation for a system of extraordinary biological productivity. From the producers on up the food chain, through one consumer after another, energy is passed along by the rich adapted diversity of these communities in Puget Sound.

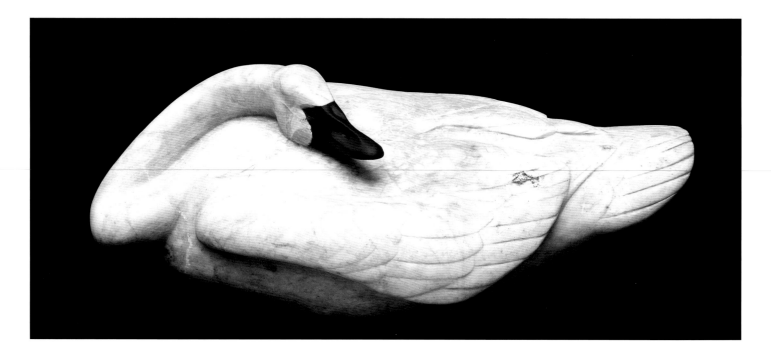

Tundra Swan, 1981
Alabaster and slate, 10 × 28 × 14 in.
Smaller than the trumpeters, the tundra swans wintering in Puget Sound are no less stunning than their larger cousin. Their black beaks and eyes, set into the creamy-colored body, are dramatic. I wanted to convey this contrast, and a block of alabaster was cut into so that a piece of black slate could be inlaid where the front of the swan's head was to be carved. In finishing the work, I shaped the slate to accommodate the details of the bird's dark beak and have it conform to the contours of the alabaster head and neck.

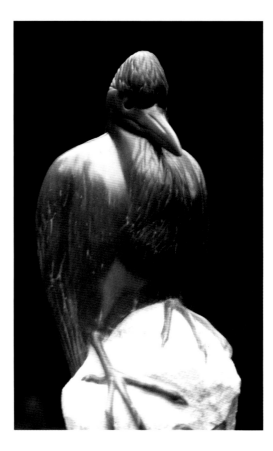

Great Blue Heron, 1992
Marble, 18 × 7 × 9 in.
A versatile species, the great blue heron has done well in Puget Sound. Moving with haughty elegance on its long legs, it can step through grassy fields as easily as it wades the shore shallows hunting for a meal. What a hawk might not see from the air, the heron pins to the ground with its beak or spears below the surface of the water. Years ago, on our way to my studio for the eighth birthday party of my twin daughters, I picked up a road-killed heron and later, on request, skinned it as part of the party entertainment. Much to my daughters' and their young guests' surprise, I removed five fresh voles from the stomach of the heron. As I recall, there was little appetite for birthday cake that year.

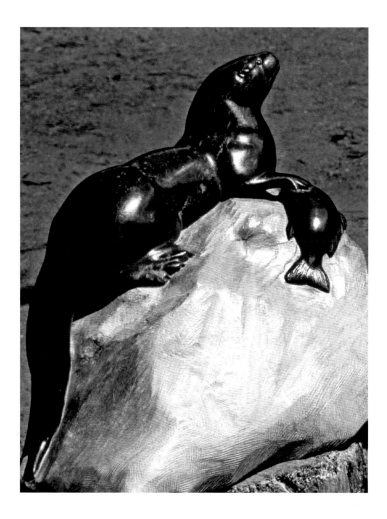

Otter with Catch, 1979
Chlorite, 14 × 17 × 12 in.
This work was intended to show the contrast between the tense and alert otter and the limp and lifeless prey draped over the rock, as I was curious as to what the stone would be capable of conveying. When I finished the piece, I discovered that it also suggested that the otter, not unlike a falcon, remains alert to the possibility that a larger animal may steal its catch. Perhaps I had this possibility for a design in my subconscious. This is a single stone; the polished and waxed otter brings out the black-brown color of the chlorite, while the otter's rock is left an unpolished gray.

estuary, waterfowl such as the Pacific brant are particularly dependent on the eelgrass beds for grazing. Even in death and decay these grasses continue to nourish as they become laden with epiphytes that feed tiny detritivores. These in turn are fed upon and contribute to the vitality of the food chain supporting the fisheries in the Sound.

Ivar Haglund, Seattle's legendary seafood restaurateur, liked to say that when the tide was out in Puget Sound, dinner was served. An evocative metaphor for us, it's even more apt for the marine birds and mammals that occupy our shorelines. At low tide, mudflats and eelgrass beds are accessible to wintering sandpipers that gather to snap up and probe for invertebrates. Herons wade patiently in the shallows stabbing small crabs, flounders, and soles. Sometimes skates are found seining for food in these brackish waters, while from the surface red-necked and Western grebes join loons and guillemots to dive for herring and sandlances. Eagles, opportunists that they are, routinely come here, cutting back and forth overhead scanning for washed-up carrion or living prey that appears vulnerable to capture.

During the late summers of the 1970s and '80s, my friend, artist and found-ryman Tom Jay, would organize a river run in wet suits down the Duckabush. With snorkels and face masks, we would have a chance to look beneath the river's hurried and restless surface as we floated slowly toward the estuary on the Hood Canal several miles downriver. Along the way, an otter or mink would occasionally be seen hunting the banks or fishing the clear waters.

It was, however, the returning chum salmon and steelhead that we hoped to see on our river runs. By drifting motionless we didn't spook the fish, and small, tightly bunched schools of them dashed beneath and alongside us. They were relentless silver missiles, guided by chemical clues in the water and resolute in their efforts to return to their natal sites to spawn. Their cold, indifferent eyes gave us scant notice as they slipped into the seams of least resistance in the river's current and flashed out of sight.

Arriving in the estuary, the river's current ceased, leaving us suspended at the surface. Those days the water was clear of algae, and we were provided a view of the alluvial sill that fanned out beneath us. If we studied the bottom of sand and silt in these shallow waters, the faint outlines of soles and flounders, settled into the sediment, could be seen. A dive over the fish would send them bursting forth out of a murky cloud to flutter like bright birds into the gloom of deeper waters. What splendid excursions those were, as they required little more than time but gave incandescent and lasting memories along with cherished camaraderie.

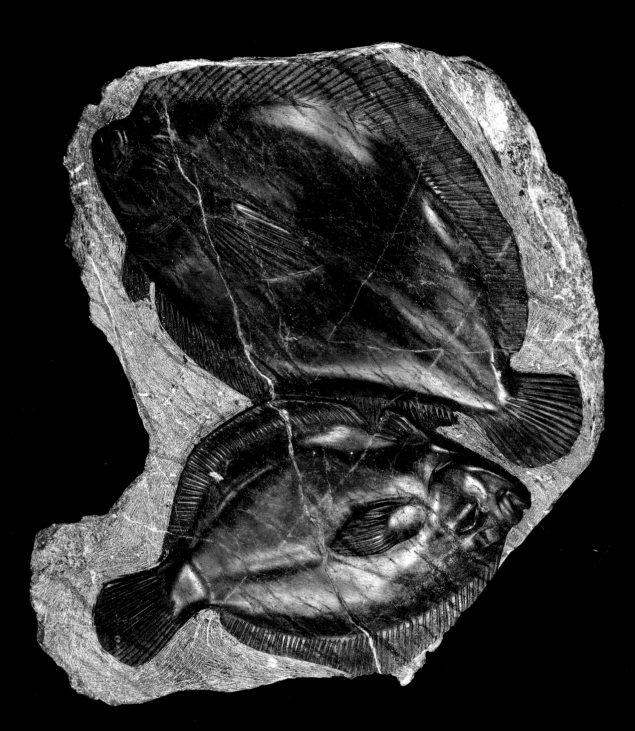

Flounders, 1985
Serpentine, 2.5 × 10 × 18 in.
We don't often realize that there would be very little to see "on" Puget Sound if what went unseen beneath the water's surface were not thriving. With little more than a face mask and a snorkel, a float into an estuary can take one into a community of life rarely witnessed. In the shallows near the river's mouth wafer-bodied soles, sand dabs, and starry flounders settle into the fine sediment. If disturbed, they erupt from the bottom in a cloud of debris to sail into the distant gloom of deeper waters.

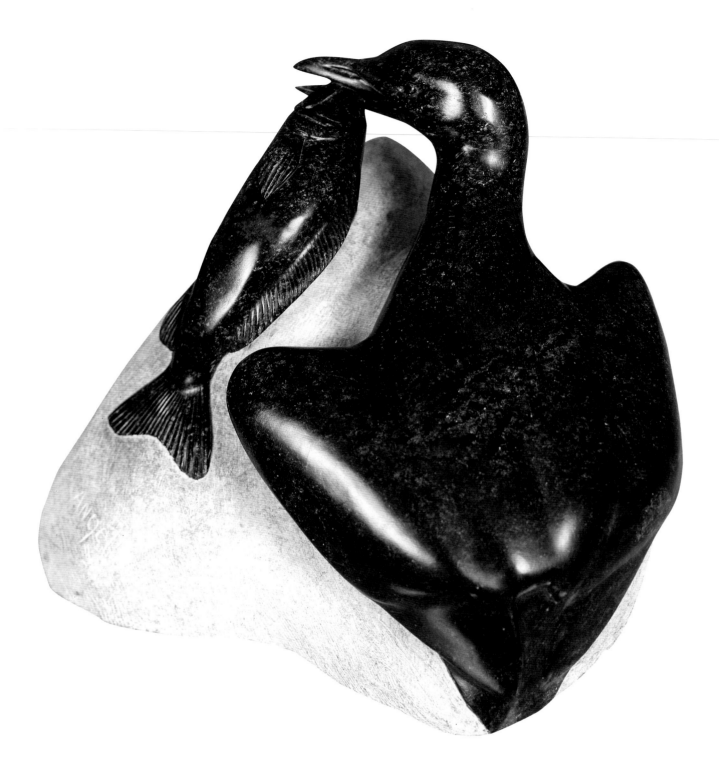

Fishing Loon, 1993
Chlorite, 12 × 15 × 15 in.
Over the years, I've watched wintering Pacific loons fish amid the turbulence of Cattle
Pass at the entrance to San Juan Channel, between San Juan and Lopez islands. The
nutrients in the water are stirred up, and marine life is nourished. One loon emerged with
what appeared to be a young greenling that seemed too large to swallow. However, there
was no problem, for, following an adjustment of the catch, it was quickly bolted down.

ALONG CLIFFS AND THE ROCKY FLANKS
OF ISLANDS, REEFS, AND HEADLANDS

In all things of Nature there is something of the Marvelous.

—ARISTOTLE, "PARTS OF ANIMALS"

Turbulent waters cut and scour basalt headlands, islets, and reefs within the San Juan Channel. On Lopez Island, my wife Lee, along with our children, Gavia and Larka, like to take the salal-lined path out to Shark Reef to walk above its ragged shoreline. On one bright winter afternoon as we faced the north edge of Deadman's Island at the entrance to San Juan Channel, we found the waters there filled with nearly one hundred Pacific loons. Currents had stirred up food for schools of small fish, and the birds, some already resplendent in their breeding plumage, were getting their share. One after another they dived then surfaced with catches that shone like fragments of polished steel. Bolting them down, they then plunged again. A pair of eagles were attracted by the energetic feeding and for a time made alternating stoops, seeking to exhaust and pick off one of the divers or perhaps pirate its catch.

As we watched, I felt a tug on my arm. My daughter Gavia pointed out a harbor seal in the water immediately below us and only a few feet from where we were standing at the crest of the basalt wall bordering the channel. Its face appeared as a silver disk, extending well above the waterline. In its mouth was a starry flounder, and so absorbed was it in its meal that it paid us no attention. With a shake of its head it peeled away the fish's skin, exposing chalk-white flesh. Another muscular move and the fish snapped in half, with one portion settling on a ledge below the seal. We could hear the crack and snap of bone and cartilage as the two-hundred-and-fifty-pound mammal chewed and crushed the fish. Looking like a portly chef I know, the seal swallowed hefty chunks with eyes closed, suggesting great satisfaction. In a few minutes the meal was over, with only bits of skin and flesh remaining to swirl about in the turbulence left

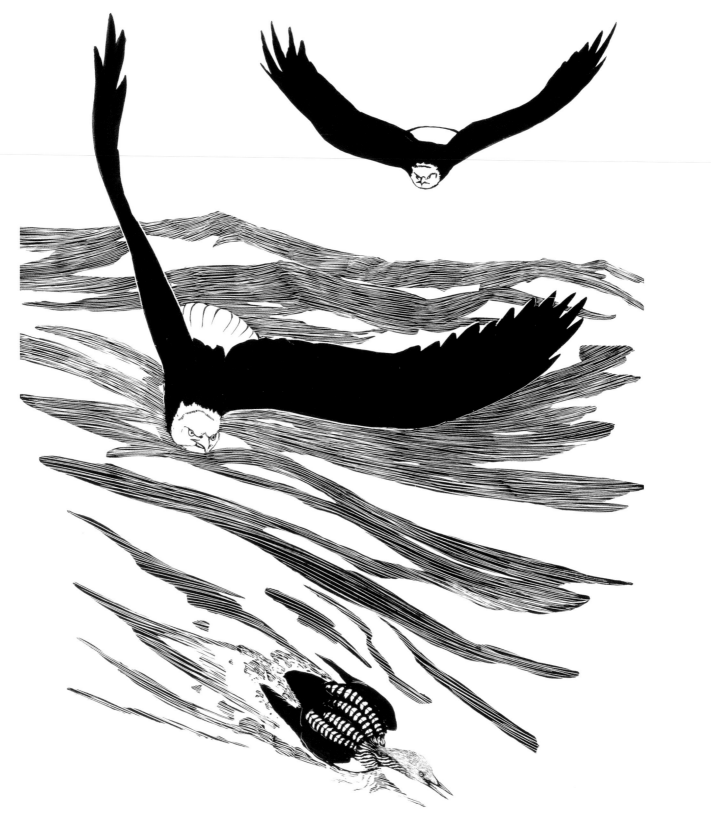

Eagles Pursuing Pacific Loon, 1985
Ink drawing, 20 × 17 in.
Bald eagles will occasionally team up to take alternating dives at fishing marine birds
in the hope that they will discourage their catch—or, better yet, that the birds will get
winded and themselves become a meal for the hunters.

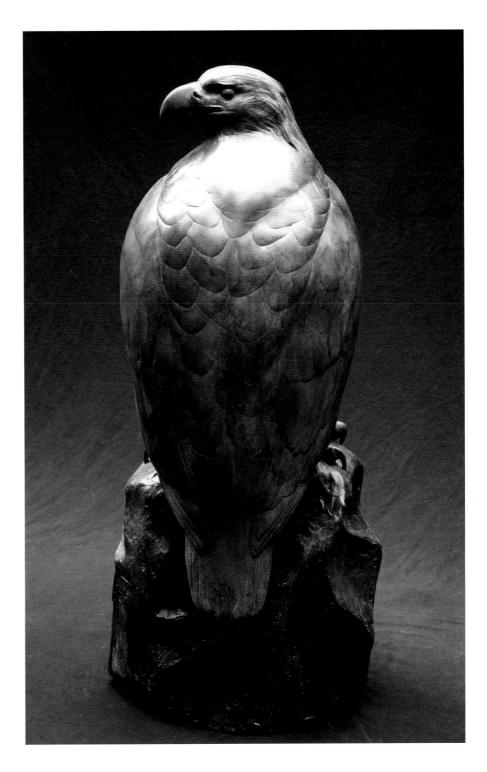

Young Eagle, 2004
Bronze, 4 × 1.6 × 1.4 ft.
Unlike some birds in
Puget Sound, eagles—
along with swans, snow
geese, and peregrine
falcons—have increased
their numbers over the
past quarter century.

from the feeding. The sated seal sank out of sight, its silver flanks flashing as it disappeared into a bed of kelp. Some of the flounder's remains drifted on the current, and harlequin ducks, glaucous-winged gulls, and herring gulls flew in to position themselves to pick up the leftovers. Where a small portion of the fish had settled on a ledge, hungry rock crabs scuttled out of recesses to investigate, and small blenny dashed about in water still cloudy with fish blood.

The surging tides and currents along these shores require that the resident plants and animals have a means to anchor themselves or a place to retreat to lest

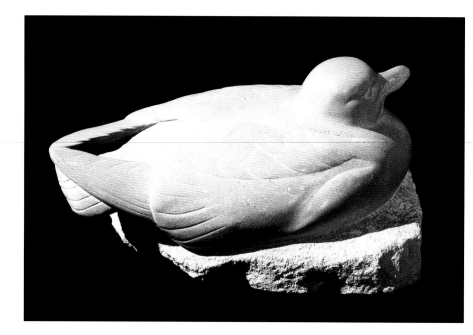

Glaucous-Winged Gull, 1995

Limestone, 6 × 14 × 7 in.

Adaptable, aggressive, and willing to eat almost anything, the glaucous-winged gull is doing well in Puget Sound. I admire the muscular shape and confident bearing of these big birds, although as a naturalist I regret that in their increasing numbers they may be outcompeting less aggressive, more specialized species.

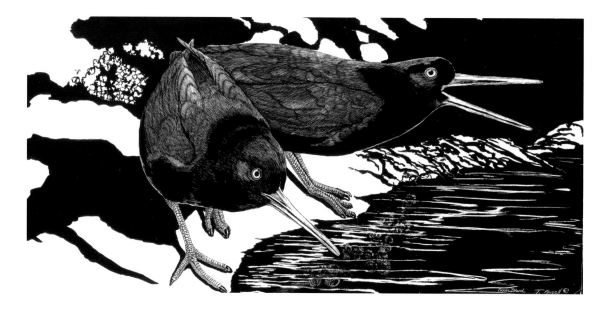

Black Oystercatchers, 1982

Ink drawing, 10 × 17 in.

Adapted for life on rocky shores and reefs, the thick-toed, heavy-beaked black oystercatcher is a flamboyant presence along Puget Sound shores in springtime as the males whistle and dance before their mates or chase rivals from their territories.

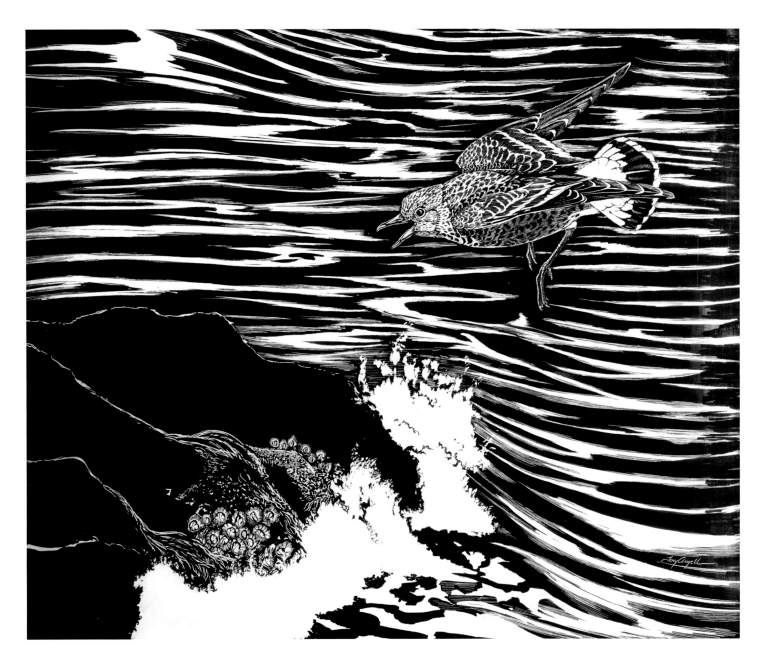

Surfbird, 1982
Ink drawing, 20 × 17 in.
Like other shorebirds in Puget Sound, the robust surfbird winters here before returning
to the Arctic to breed. It thrives along our coastal reefs and rocky edges, where it moves
in to feed between the crash and spray of the surf.

they be swept away and lose access to the nutritional beneficence of the rush-
ing waters. In a dive or when the tides are low, a person can find assorted algae,
anemones, barnacles, mussels, small fish, and crabs seeking to attach to every
surface or to wedge into and hide in stony crevices. In still deeper waters are
rock scallops and abalones.

Within the intertidal zone, black oystercatchers have adapted to harvest
many of the shellfish living here. With stout beaks they stab, chisel, and pry

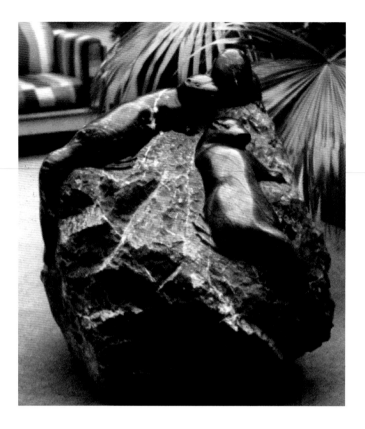

Otter Family, 1983
Serpentine, 4 × 4 × 3.6 ft.
River otters are sociable animals. Watching them chase, fish, play, and lounge together on exposed reefs, taking in the sun, suggests that we have common ground with these cohorts in Puget Sound. For a couple of decades, this piece has stood beneath the atrium of the Olympia Timberland Library, where young children routinely climb onto the stone to join the otters for a moment under the sun.

their way into the armored life to extract a succulent mussel or limpet from its casing. Along these shores and on the islets, wintering surf birds and turnstones come to feed on the rocks, hustling about and over the resting harbor seals and California and Steller's sea lions.

The islets and exposed reefs are particularly important as sanctuaries and retreats for marine life in the Sound. Throughout the year, wildlife can find solitude here, away from the threats they would be exposed to on the mainland. No off-road vehicles, intrusive hikers, or wandering dogs and feral cats disturb them. On the offshore rocks and cliff faces, pelagic and double-crested cormorants can stand undisturbed, wings outstretched, to leisurely dry their feathers between dives. Harlequin ducks haul out and join company with resting pigeon guillemots and surf birds. Come summer, flocks of red-billed Heermann's gulls, looking sleek in their suits of gray plumage, migrate here from Mexico.

The same remote conditions that assure some rest and retreat for our marine birds also provide secure nesting locations. Our common gull, the glaucous-winged, has successfully established large breeding colonies on the more isolated

offshore locations, such as Colville Island, off the southern end of Lopez, and Protection Island in Discovery Bay, along the Strait of Juan de Fuca. Oyster-catchers breeding on these islands and exposed reefs require little more than a dry gravel or sand bed between rock outcrops to scrape out a nest bowl and lay their clutch of one to three eggs. Protection Island has been a preserve for some time now, as a result of the energetic efforts of individual conservationists and the cooperation between environmental groups and state agencies. It is the most important marine bird breeding site in all of greater Puget Sound.

While gulls breed on the level ground of the island's interior, the cliffs provide shelves and niches suitable for breeding pelagic cormorants and pigeon guillemots. The soil along the outer edge of the island is such that rhinoceros auklets and rare tufted puffins are able to dig into the soft substrate to form

Totemic/Sunning Cormorant, 1998
Bronze, 20 × 38 × 10 in.
Emerging from their fishing dives and their extended time on the water, cormorants require periods out of the sea to dry their wet plumage. Wings out, pelagic, double-crested, and Brandt's cormorants strike totemic poses against rocky cliffs or atop the remnant supports of abandoned piers.

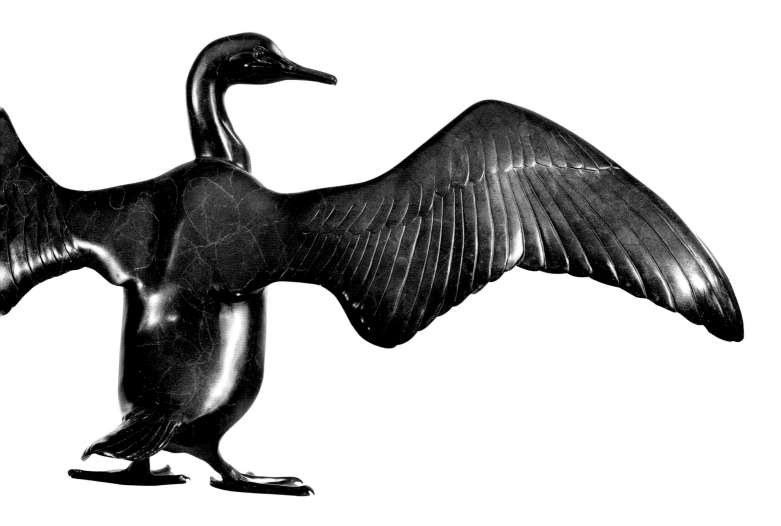

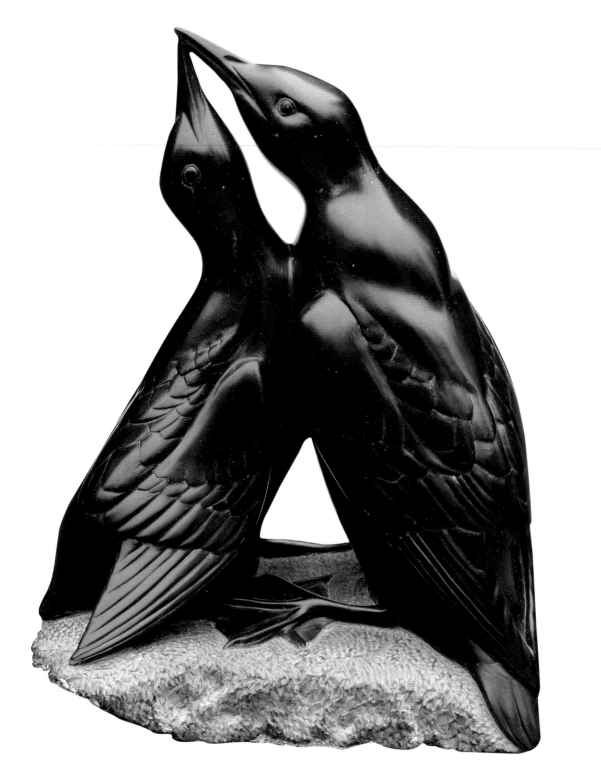

Sea Cliffs/Guillemot with Young, 1987
Slate, 12 × 7 × 5 in.
Castle Rock, the south end of Lopez Island, and the flanks of Protection Island have
been good places to watch pigeon guillemots feed their hungry young. The solicitation
for a meal is anything but subtle as the fledgling bumps chest-first into the adult and
thrusts its beak upward toward the parent's head. Engaged in this ancient ritual, the two
birds strike angular and animated poses on the sea cliff.

Brooding Falcon, 1985
Steatite, 10 × 14 × 10 in.

A half century ago, breeding peregrine falcons were all but extinct in Puget Sound. With the banning of DDT and other persistent pesticides, however, the toxins in the birds' diets have diminished, and today they are once again raising families here. From across a bay near my studio, I've watched these falcons brood their young on a ledge so narrow that I worried that the youngster might fall into the water below before it fledged. It never did, and I was reminded that this precarious arrangement might be the falcon's strategy to avoid predation from land or air. Other than a climber rappelling from above, no mammal could reach those nests, and a great horned owl or eagle, the falcon's greatest threats, flying into the cliff face with little to perch on, would find predation very difficult. This piece remains a metaphor for me of the peregrine falcon's recovery and of responsible stewardship in the San Juan Islands.

nesting chambers suitable to raise their young. After a long absence, peregrine falcons have reclaimed breeding territory in the more remote sea cliffs of northern Puget Sound. In the late 1960s and early '70s, scientists throughout North America and parts of Europe made the case for banning the persistent pesticides that were contaminating the falcon's diet, and within a decade its numbers began to slowly increase. Conservation organizations in Washington, such as The Nature Conservancy, worked with state wildlife and land managers to protect the falcon's habitat, and pairs returned to breed.

A few years ago, when my artist friend John Busby and his wife Joan were visiting from Scotland, we were standing opposite a peregrine falcon's cliffside

nest, gathering ideas for drawings and sculpture and speaking optimistically of
the bird's continued recovery, when the female falcon, carrying prey, flew into a
stand of madronas and cedars above us. She called across the bay that separated
her from the nest on the cliff face. It was early in the day, and the single hun-
gry youngster had yet to be fed. Seeing the meal she had in tow, the nestling
responded with vigorous wing flapping and begging calls from the narrow ledge.
In spite of its hunger, however, the young peregrine wasn't confident enough
to fly out and cross the three-hundred-foot expanse of water that separated it
from the parent. There seemed to be a standoff until the adult began to pluck
her catch. Puffs of dark feathers floated out from the bank of trees and drifted
toward us. This was enough to launch the young bird, and with choppy wing
beats it gathered sufficient momentum to fly over to its mother and a meal. The
begging cries continued and were interrupted only by the fledgling's choking
swallows as it bolted down one mouthful after another. Feathers on the breeze
were descending from the trees above us, and I reached up and cupped a few in
my hand. That morning, band-tailed pigeon was being served.

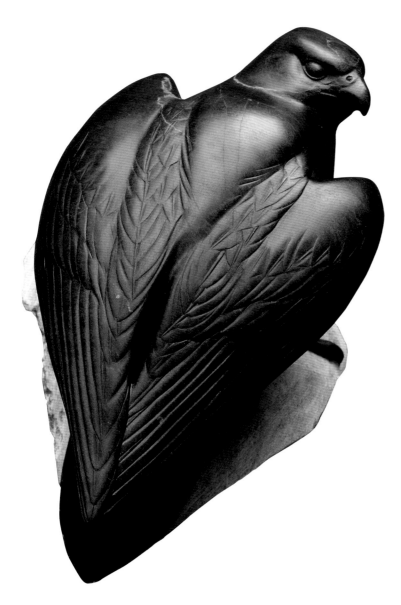

Falcon on Prey, 1985
Chlorite, 15 × 10 × 12 in.
I watched a falcon fly inland, having caught
a dunlin in midair over the water. She landed
in an open field to eat, and through binoculars
I could see her scan the immediate vicinity for
any threats. Seeing none, she began to feed.

Glaucous-Winged Gull Family, 1982
Ink drawing, 12 × 17 in.
Remote from human activity, islets in Puget Sound provide safe retreats for breeding colonies of glaucous-winged gulls, tufted puffins, rhinoceros auklets, pigeon guillemots, pelagic cormorants, and black oystercatchers.

Even the sheer cliffs of an aerie or a moat of saltwater surrounding a nesting place doesn't secure breeding birds from all threats. In the San Juans, great horned owls have killed brooding adult falcons and their fledgling young. Bald eagles fly out to island gull colonies to take young, and river otters swim over from the mainland to catch what they can. In the late spring of each year hundreds of families of glaucous-winged gulls on Colville Island must contend with the bald eagles that descend into their midst seeking the youngsters not yet able to fly. In the breeding season, I hear the din of screaming adult birds from my studio as they rise up defensively in a swirling, shrieking mass when eagles head their way. The gulls' frenzied ascent has little effect as the dark-backed, white-headed hunters set their wings and stoop through the hysteria to snatch a young gull from the ground in a single arc. Since there seems to have been no decrease in the population of this most common gull, and our resident eagle population has increased in recent decades, it appears that this arrangement has worked well for both species.

Black Turnstones, 1982
Ink drawing, 17 × 20 in.
Keeping company with black oystercatchers, surfbirds, and wandering tattlers, flocks of wintering black turnstones fly in tight formations from rocky beaches to reefs where they probe and pry for hidden marine invertebrates.

FOUR

ALONG BEACHES OF COBBLE AND SAND

Heaven is under our feet as well as over our heads.

—THOREAU, *WALDEN*

Flotsam pitched high on the shore by a recent winter storm was laid out before me in long lines as I walked along the shore, inspecting it for intriguing fragments of feather, bone, and shell. I knelt to pick up an intact crab carapace that seemed to have bite marks, suggesting that an otter or an eagle might have had this crustacean as a meal. The moment my knee hit the ground, the beach a step or two ahead became a whirlwind of wings. Startled, I looked up to follow a ragged, black-and-white patterned cloud as it sailed away along the waterline before descending back onto the shore, where it disappeared amid the cobble and debris. I had been so focused on my "forensics" that I had failed to notice the flock of black turnstones. They had not considered my focused behavior as a threat and moved along just before me as I studied the ground. My sudden change of posture, however, set them off.

These are shorebirds that look under things, and I watched them employ their rigid, slightly upturned bills to flip, probe, pry, and sweep over and into what might conceal a meal. The flock came upon a pile of bull kelp that had washed ashore and there joined a pair of semipalmated plovers in a rush to snap up beach hoppers feeding on the rotting algae.

One summer, on a Lopez Island beach, I came upon a line of a dozen rhinoceros auklet bodies. So neat was the row that the birds appeared to have been placed there by something other than the last high tide. Picking one up, I found that its wings and legs were quite flexible and that the cartilaginous horn on its beak was still bright and fresh. One by one I looked at the gray plumaged divers still flamboyant with their jaunty and elongated mustaches and brows of yellow feathers. Each bird had a circle of compressed feathers across its chest, neck, and back. The story of their deaths was told there. They had been inescapably snagged by a gill net set offshore. Seeking their share of herring among

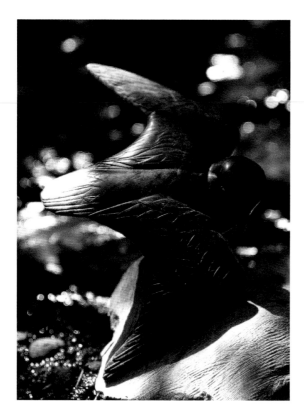

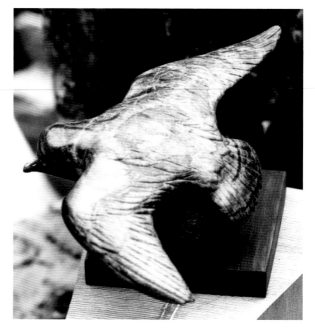

Plover in Flight, 1982
Serpentine, 6 × 5 × 5 in.
The patterns in this stone suggested the dynamic
and hurried propulsion of a plover in flight.

Plover in Flight, 1983
Serpentine, 8 × 6 × 4 in.
The semipalmated plovers scurry above the line
of surf, snapping up prey from the beach's surface.
Diminutive and stout of body, they add lively and
animated character to our beaches as they move
through Puget Sound in their winter and spring
migrations.

the feeding salmon, they had been netted beneath the surface, where they had
drowned.

The dynamics of Puget Sound currents, tides, winds, and rains continually
erode material from the land that is swept along to be collected between head-
lands to form beaches. Here scores of specialized shorebirds come to feed over
and under the surface. A small flock of sanderlings race to keep their numbers
at the front edge of a wave that has broken over the beach. It's here that they
can capture an animal that momentarily emerges. Sandpipers and plovers dance
about to catch flies swarming about the strands of beached kelp that have bro-
ken off in a storm. When not on the islands or reefs, oystercatchers visit these
locations to opportunistically lever into shellfish they find.

Embayments with beaches and bottoms of cobble and rounded gravel are
important to marine mammals as well. Orcas in particular occasionally scrape
their bodies over these substrates, taking what amounts to a cleansing scrub over

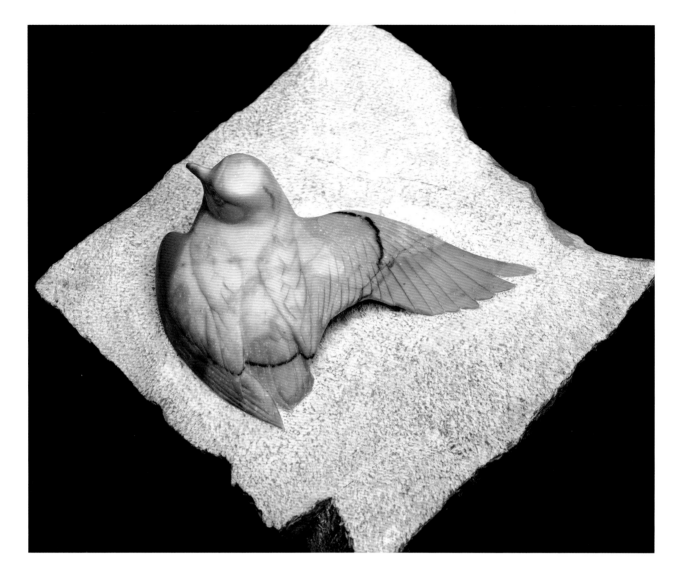

Plover in Display, 1995
Sienna marble, 4 × 11 × 10 in.
When plovers pause to stretch and preen, the charm of their design is fully realized.
I'm intrigued, too, with the contrast that I might explore sculpturally in the stone
between the silky plumage of the bird and the gritty, shell-covered beach it rests upon.

the bottom. The process cleans the surface of their skin, removing parasites and
patches of old skin. I've watched otters and harbor seals do essentially the same
thing on land: diving obliquely into the piles of gravel at the surf line and push-
ing themselves steam-shovel fashion through the loose material. There's more
than grooming going on here; judging from the repetition, I would say that the
otters were getting something close to a belly- and back-scratching massage
from the action.

Looking down from island bluffs, I occasionally see otters fishing along the
surf line. Singly or as pairs they drive their prey into shallows where escape is
less likely. From a ridge near Point Colville on Lopez Island, I watched an otter

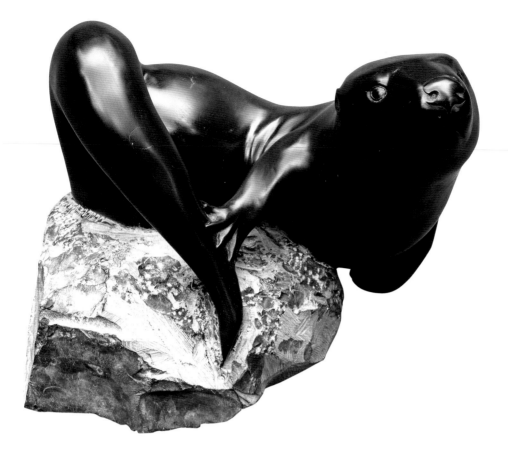

Grooming Otter, 1999
Black marble, 10 × 15 × 10 in.
Apparently never knowing that I was watching, this otter spent a quarter of an hour rolling about on the warm cobble beach to scratch her back before settling into a long grooming session wherein she combed her luxuriant tail with her forepaws as a woman might run her hands and fingers through a healthy head of hair.

thrashing about in shallow water. It moved my direction, and once it was close enough I could see that it was pursuing a small red rockfish that flashed brightly in the overhead light of midday. With the otter between it and the open water, the fish was cornered as it raced back and forth just short of being beached. I was expecting the otter to close the distance and have its meal when suddenly it grabbed the fish's tail in its teeth and flicked it out into deeper water. Nearly in the same motion, the otter then plunged back into the chase and again herded the fish toward the shore. After three or four of these pursuits, the fish was about done in. "First the games and then the meal," I thought as I waited for the otter to feed. To my utter amazement, the mammal swam up, nudged the fish with its muzzle as if to say "games's over" and then bounded out of the water and onto the beach, where it rolled about briefly on the warm gravel before heading into the drift logs below the bluff I was watching from. Checking on the rockfish, I saw it recover sufficiently to swim back out to deeper waters.

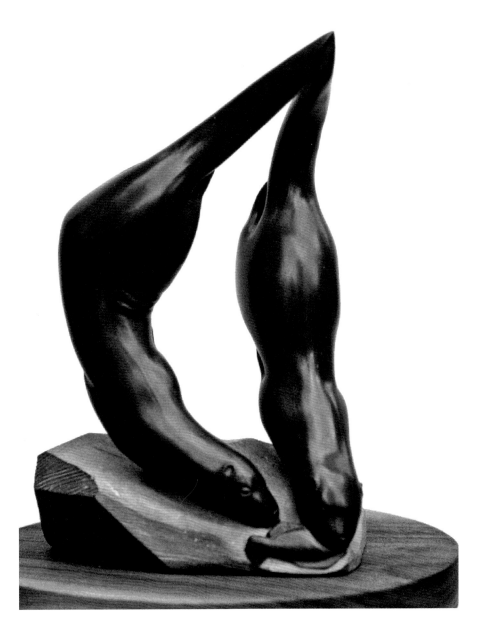

Otters at Play, 1988

Slate, 10 × 5 × 3 in.

For the most part, the lives of marine mammals in Puget Sound
are carried out beyond our sight, below the water's surface, on remote beaches and reefs
and in rocky recesses. With patience and good luck, we can occasionally catch an intimate
glimpse. From the bluffs above Watmough Bay on Lopez Island, I have looked down
into clear waters and watched otters spiraling about in play. They corkscrew down deeper
and deeper to disappear into the blue-green shadows of some secret grotto.

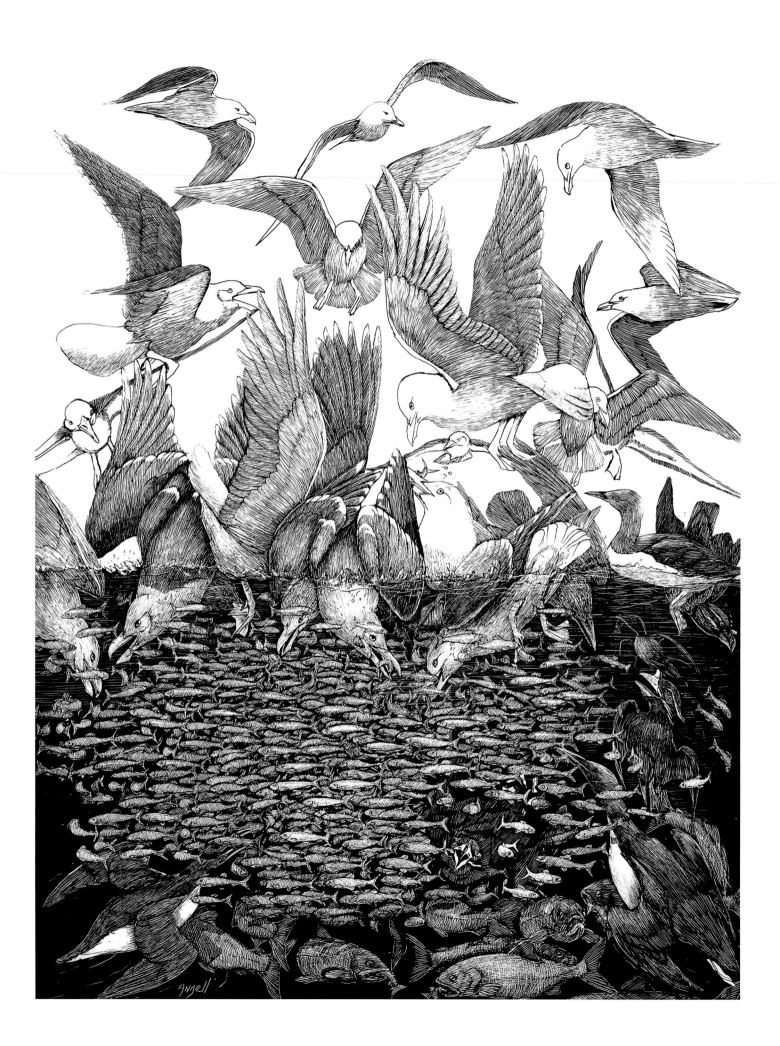

AT THE NEAR SHORE

AND ON THE OPEN WATERS

It is life near the bone where it is sweetest.

—THOREAU, *WALDEN*

I t was early summer as I looked southwest across the Strait of Juan de Fuca from the top of Chadwick Hill on Lopez Island. The sea's surface gently heaved, suggesting the presence of some great being stirring within. Using binoculars I followed hurried lines of cormorants, guillemots, scooters, and rhinoceros auklets. On a mission, their flight was straight ahead and sure. In the bay below, a gang of a hundred gulls swirled, surged, and plunged into a herring ball near the surface. In all likelihood the fish had been herded there by diving auklets and murres or even a school of salmon. I could hear the frenzy in their calls as they competed for the food—and so, apparently, could other gulls, who detoured from their flight line to join the melee. These cries rang like dinner bells to other gulls.

Off our beaches, just beyond the intertidal zone where a rocky bottom affords anchorage, kelp can flourish. In some of its forms a strand of this algae can grow nearly a hundred feet over a single year. Photosynthesizing energy from sunlight and absorbing nutrients directly from the saltwater, dense stands of kelp provide

Feeding Frenzy Over and Under, 2008
Ink drawing, 17 × 20 in.
From a distance I can see the turbulence over otherwise quiet waters. A feathered storm is raging as gulls on the wing race from all directions to plunge into the waters over a ball of herring. We see only a fraction of the action. The thousands of herring are out of view, as are the diving murres, auklets, and guillemots, who, along with the salmon, have herded the small fish toward the surface, making them accessible to the gulls.

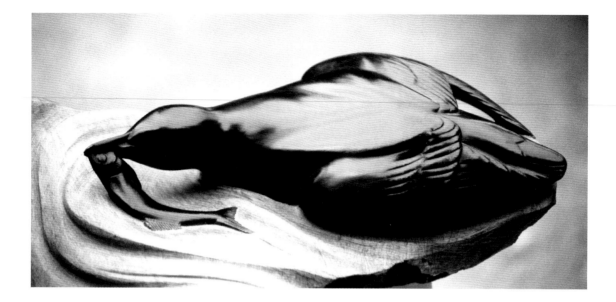

Guillemot with Fish, 1985
Chlorite, 4.5 × 15 × 16 in.
Where sandy bluffs loom up from the shore, guillemots will excavate burrows to raise
families, and in early summer I watch the adults pitch off from their high ledges to sail
into the center of the bay below to fish. In a dive, they extend their wings slightly to
scoop themselves into the water's depths, where they may remain for a minute or more
in search of stickleback, herring, or blinny. Reappearing at the surface, they adjust their
catch for a better grip then run across the top of the water to become airborne. Circling
about once, twice, thrice to gain altitude, they then head straight to the nesting cavity,
where they plunge in with their meal for the young.

an indispensable habitat for marine life in a manner not unlike the complex
biological services provided by beds of eelgrass in the less turbulent estuarine
waters or in forests of the uplands. The blades of decomposing kelp nurture the
invertebrates that in turn become food for small fish and crab that are them-
selves the mainstay of larger fish and a range of diving birds. Thick clusters of
kelp can be close to impenetrable. This density makes it an ideal place for retreat
and protection for schools of herring and populations of perch and greenling.

It's an easy swim from the beach out to the mouth of McArdle Bay, and from
there, if the tide is right, one can cross over to Castle Rock. Fifty-foot "hedges"
of kelp loom up from the craggy sides of the bay's headlands and sway like trees
in the wind in the give and take of the currents. When I push my way into the
bed it is as if I'm entering a rainforest at its margin where sunlight has fueled
a thick wall of plant life. I always feel some uncertainty here, as I'm never sure
what might be on the other side of this curtain. When the blades of kelp are
swept aside, exposing the cliff face, I look for abalones and rock scallops that

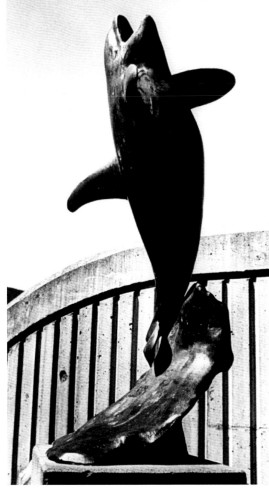

Breaching Orca, 1977
Bronze, 8 × 2 × 2 ft.
In Puget Sound, the presence of our resident orcas, an iconic species, is almost entirely dependent on the populations of wild salmon. Without healthy rivers, creeks, and streams in the Puget Sound basin, our fish runs would further diminish, and in turn our great pods of orcas would be no more.

are momentarily revealed. Pulling and pushing slowly through the shifting blades brings me into an open chamber between the beds where a silver school of herring swirls before me like some bright geyser. It expands and contracts as thousands of fish move from the outside edges of the school to plunge into the swirl of brethren seeking anonymity.

Harbor seals and river otters probe these kelp beds as well, hoping to surprise fish. Our local orcas give kelp beds the once-over on the chance that some fish of size might be flushed from their confines. Once, returning to shore from one of my dives for abalones, I learned that a half dozen orcas had cruised around the kelp bed within which I was fishing. Anxious friends on the beach had been waving at me, but I had had no idea that it had been to alert me to the presence of these big mammals. They later told me that at one point the orcas had been only a few yards from me. That a number of these ten-ton mammals could be swimming so close and that I could remain unaware of them speaks to their remarkable power of stealth and to my relative lack of alertness.

Once, seated on the edge of an exposed offshore reef, my diving partner, Dave, suddenly exclaimed that something had wrapped itself around his ankle. I looked down and saw the long tentacle of an octopus extended from a recess

in the rock, tentatively exploring Dave's leg. This exceptionally curious animal was trying to make "sense" out of the intrusive hunk of flesh that blocked its den entry. The octopus had the confidence to fully emerge, and within a minute Dave's leg was embraced by eight inquisitive arms. A move to shake the animal off its perch changed its curiosity to fear, and with a propulsive thrust of water and ink it retreated back into a cleavage in the rocks. In a world increasingly stirred by the heavy hand of humankind, an intimate meeting with an inquisitive and innocent wild cohort is rare and cherished.

As terrestrial creatures, most of us view the open marine waters of Puget Sound from a distance and see only its surface. Its immeasurable biological richness and the threats to its vitality are rarely considered. When we see life on or in the waters here, it is usually something big and obvious. Eagles overhead, orcas breaching, or a gathering of gulls along the shoreline. These species are here only because a healthy, unseen, and underappreciated system of life undergirds their feeding, resting, and reproduction requirements. Watching the blues and greens of the swirling currents and the frothy white caps in a storm doesn't suggest what life might be living along the water's surface. The almost paper-thin micro layer here is habitat for plankton. These near-microscopic plants and animals are what feed the tiniest fish, which in turn are the main course of the herring that in Puget Sound are the mainstay of our salmon stocks. Need I say that without the salmon our region would be barren of orcas, seals, and sea lions—not to mention any sports or commercial fishery? As with all living things, the great and powerful few exist only when the small, subtle, and unseen are abundant and healthy.

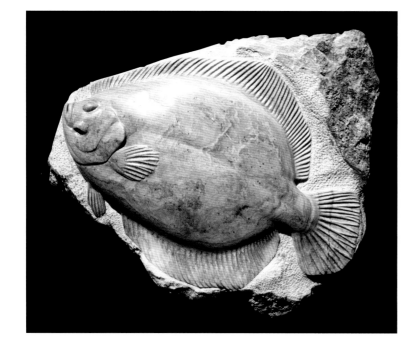

Sea Form/Halibut, 1993
Marble, 5 × 28 × 30 in.
There's a story told of a fisher who set out from Port Townsend to try his luck at catching halibut in the straits and failed to return at day's end. The following morning, his small skiff was found adrift, and, when boarded, the fisherman was discovered to be entangled by his fishing line in a fatal embrace with an enormous halibut. As large as five hundred pounds, these great bottom fish have been celebrated artistically for thousands of years by all of the people who have occupied these shores.

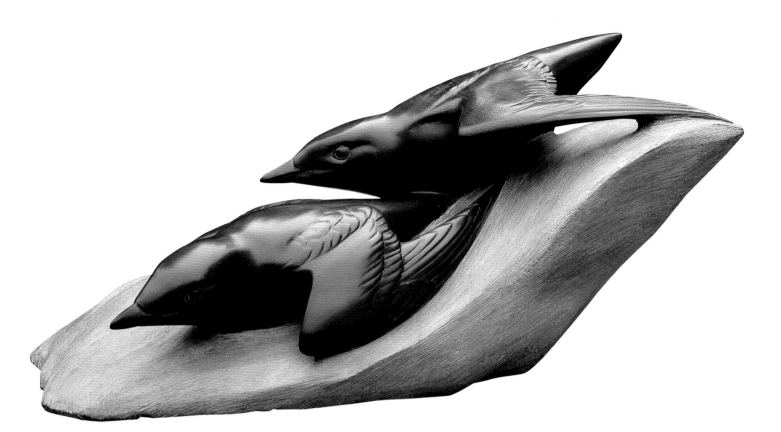

Chasing Murrelets, 1986
Slate, 6 × 17 × 5 in.
During mid- to late summer, small numbers of marbled murrelets gather to fish just offshore in the bays of the San Juan Islands. Like small, stub-tailed, brown-and-white patterned doves, they fly just above the water's surface, held aloft there by their momentum and an invisible cushion of air.

Bird at Sea, 1986
Chlorite, 6 × 15 × 8 in.
This tiny marbled murrelet lives most of its life just off our Puget Sound shores. The sea may be terribly turbulent and unpredictable in providing food, but it is the destruction of the old-growth forests where it nests that most seriously threatens this bird's future.

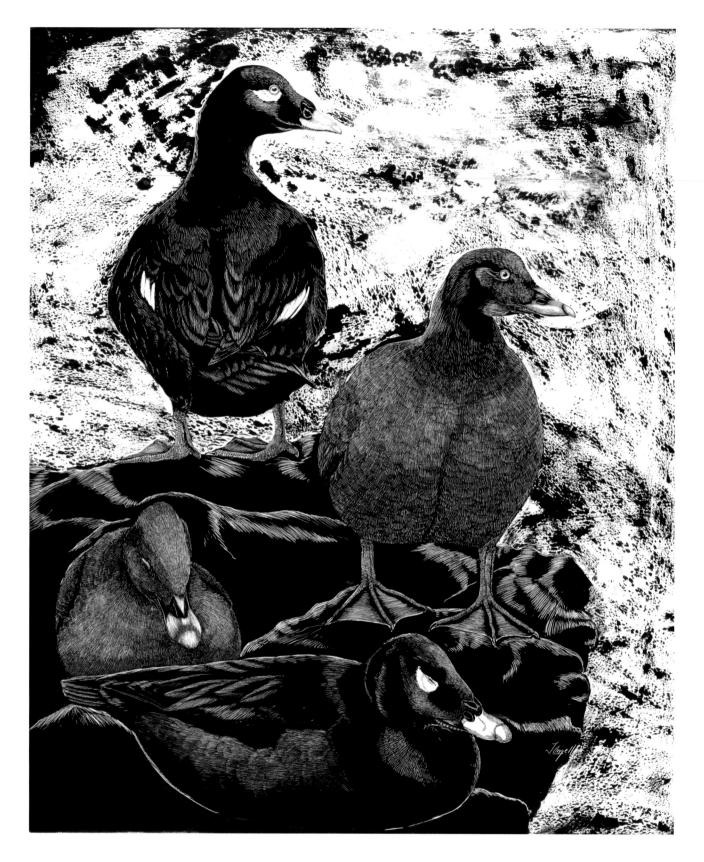

White-Winged Scoters, 1985
Ink drawing, 20 × 17 in.
Since the 1980s, all three species of scoters in Puget Sound have diminished in numbers.
Their decline is certainly due in part to the degradation of the habitat supporting the
shellfish upon which they feed. These big, strong, firmly fashioned birds are attractive
subjects for artistic interpretation.

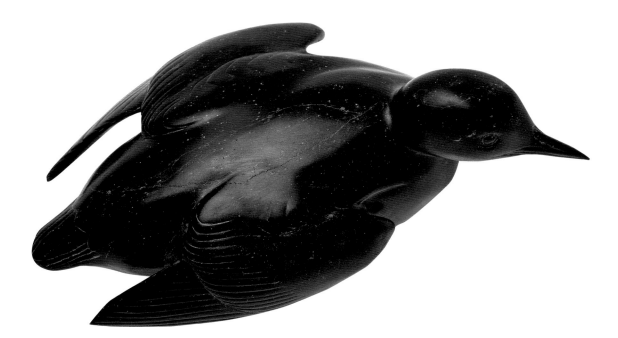

Guillemot, 2003
Black marble, 5 × 12 × 6 in.
In the spring, pigeon guillemots assume a stunning black-and-white breeding plumage.
Our resident populations of coastal falcons rely on the guillemots as a source of food.

It's a rare ferry trip during which something of interest doesn't momentarily flash a dorsal fin or wing tip, suggesting that moments of interest or even high drama might be underway. On the ferries between the islands of the San Juans, between Victoria to Port Angeles on the Olympic Peninsula, and even farther south, on the short trips to Edmonds, Bremerton, and Vashon, the ferry provides a platform for viewing marbled murrelets, guillemots, rhinoceros auklets, and murres. In numbers fewer than they were a quarter of a century ago, these birds space themselves out in small feeding flocks to fish from near shore on into the open waters of the channels. Just out from the beaches, surf, white-winged, and common scoters are occasionally seen diving for shellfish. Small flocks of northern phalarope sprint alongside the ferry only to stop on a dime and settle onto the surface to spin about, creating an upwelling that brings their planktonic prey close to the surface where it can be fed upon. Occasionally one catches glimpses of Dall's and harbor porpoises or the transient and resident pods of orca whales. Minke whales will occupy channels in the San Juans to seine for herring, and, of late, particularly in the more northern parts of the Sound, migrating gray whales detour from the Pacific Coast to plow into the soft substrate of Puget Sound bays to feed on clams.

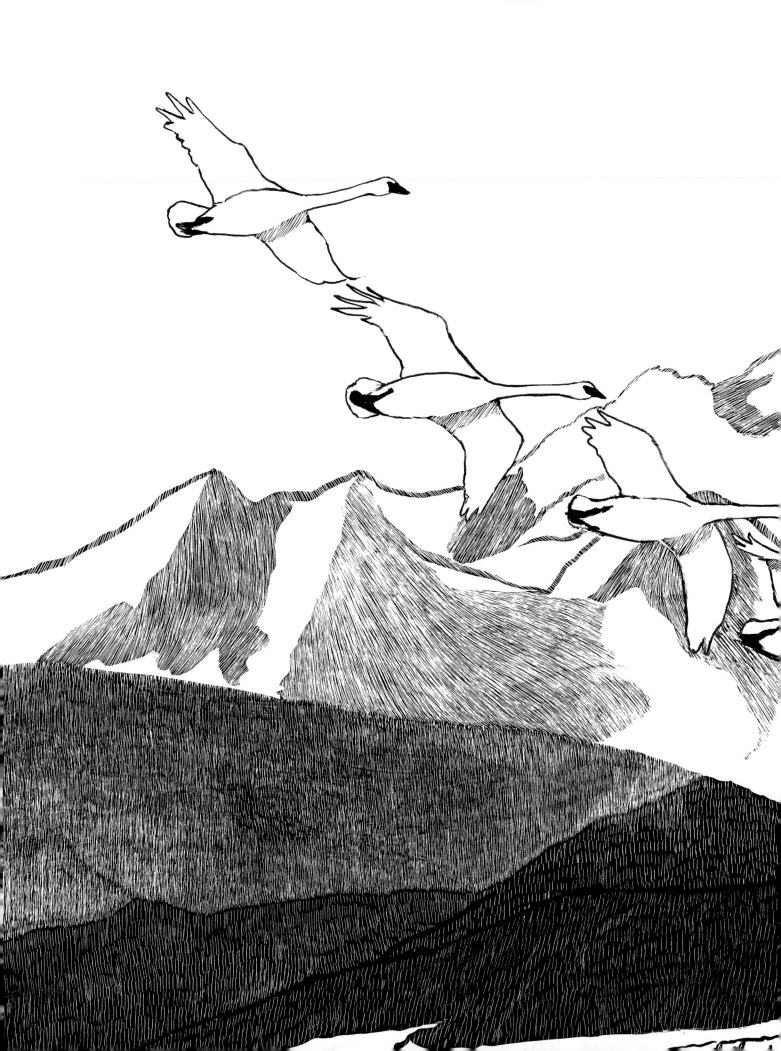

PART II

BRINGING
EXPERIENCE AND
INSPIRATION
INTO ARTISTIC
EXPRESSION

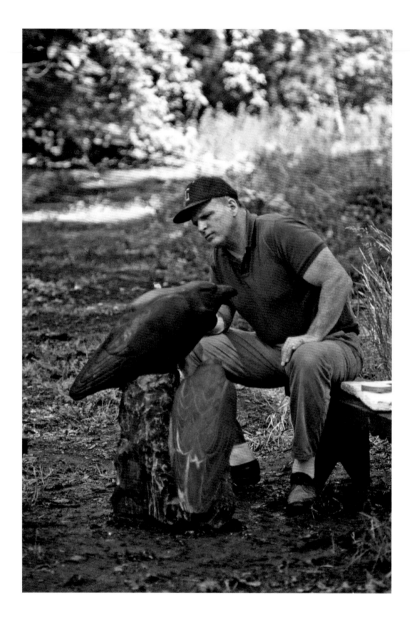

The artist at work on *Hugin and Munin*
(black marble, 2.5 × 2 × 4 ft., 1992)
The title for this piece references the ravens of Nordic mythology that regularly counseled
blind Odin on all the matters of the world that they had observed.

THE ARTIST AT WORK

It is art that "makes" life, makes interest, makes importance, for our consideration and application of these things, and I know of no substitute whatever for the force and beauty of its process.

—HENRY JAMES, LETTER TO H. G. WELLS, 1915

Great Nature has another thing to do
To you and me: so take the lively air,
And, lovely, learn by going where to go.

—THEODORE ROETHKE, *THE WAKING*

SOME BACKGROUND

I don't think I have had any choice in the matter of doing art. For as long as I can remember I've done it, and it came naturally as my most effective way of maintaining a dialogue with a world that might otherwise have remained remote and unknown. The world of Puget Sound has been my principle source of inspiration, and pursuant to this "conversation" I've illustrated and written books, carved animals in stone, and modeled them in clay and wax to be cast in bronze. Initially, I entered into these enterprises with more passion than direction or technique, but that was part of the pleasure—discovering what was possible rather than being told what to do and how to do it. Over the years, people have inquired about the processes involved in producing such work, and the frequency of these inquiries suggests that it may be useful to provide a brief description of how I work. It's safe to say that whether I'm gathering impressions from the field, working up a drawing, or finishing a carving, I've learned that patience and persistence are among my most important habits. Progress is only possible by staying with a feeling that there is something out in nature to discover and be inspired by. From that initial contact I accept the fact that

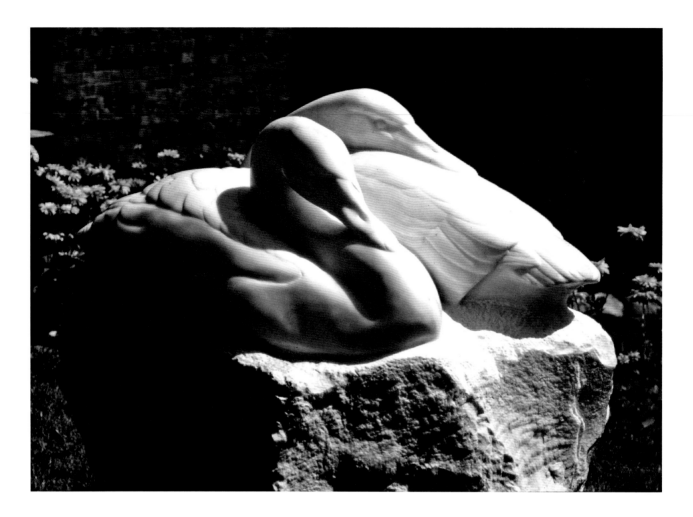

Trumpeter Swans, 1986
Marble, 30 × 33 × 27 in.
At close to thirty pounds, nearly three times the weight of a bald eagle, there are few birds larger than the male trumpeter swan that are also capable of flight. In the early 1960s, when I first watched a few swans glide into secluded ponds on their eight-foot wingspans, there were less than fifty birds to be found here. Today, back from near extinction, these wintering swans number in the thousands along the Skagit and Stillaguamish deltas.

I will likely try again and again to translate that experience to paper or shape it in stone.

I've also done this long enough to believe that what I have to say about nature through my art is distinctly different from what I might have conveyed in words. Art invites the individual to consider the world emotionally through aesthetics and on their own terms rather than as a didactic message aimed at the intellect and easily dismissed or treated with indifference.

When I was a youngster, my art served as a footing for moving through the maze of academic subjects, and it seemed that when a word was lacking or when a formula failed, I could substitute a picture to make the same point. It was sports, however, that supplied a ticket out of Southern California and the San Fernando Valley and brought me to the University of Washington on an athletic scholarship. I really never looked back, and from my seventeenth year on, if I wasn't in the classroom or competing in a track meet, I was out somewhere in the woods or on the beaches of Puget Sound.

In graduate school my artistic interests took a serious turn. While attending what is today the school of speech communication, one professor in particular, Dominic LaRusso, encouraged research in the cultures of the classical Greeks and Renaissance Italians. My sense of what might be possible in the range of human expression took a quantum leap. I was studying extraordinary times and circumstances wherein art was of paramount importance in expressing ideas and motivating people. The belief that art would play an important part in my life began to form.

Also around this same period, a brief friendship I had with the poet Ted Roethke provided a pivotal moment in determining that I ought to pursue my interest in art with serious intent. It had not escaped Roethke's notice that I was dating one of his poetry students, and one afternoon as I waited for her outside Parrington Hall, his ponderous shadow loomed above me as he stepped up and introduced himself. I was flattered, to say the least, and accepted an invitation to have a beer with him at the Blue Moon later that afternoon. A week later his wife Beatrice was serving the beer and we were playing a badminton match at his home above Lake Washington. It was within the context of these few games that we played that I drew an important conclusion. While we chatted about local bird life, women, and poetry, Roethke proceeded to win match after match. I considered myself a pretty fair player, and yet here was a poet, for God's sake, two and a half times my age, with bad hips and bad habits, who was nevertheless an exceptional athlete. As I raced back and forth, out of breath, he effortlessly pivoted at midcourt to fire back into the most distant corner of the court any birdie I managed to get over the net. I was mightily impressed by his combination of physicality and sensitivity. Creativity and athleticism are not mutually exclusive. I remember reflecting on my short but poignant association with Ted Roethke not long ago as I stood, forty-five years later, above what was once a swimming pool on the Bloedel Reserve on Bainbridge Island. A sand garden now, the pool had been filled with water in 1963, when Ted drowned there after suffering a heart attack while swimming. He had called me that morning indicating that he was headed to Bainbridge and would have to cancel our badminton game. "Maybe next weekend," he said. I read about his death in the newspaper the following day.

SKETCHING

I, like many other artists, believe that sketching is fundamental to whatever I might eventually do with a finished drawing or sculpture. Inasmuch as ideas and inspiration don't arrive on schedule, I try to keep a pencil and paper close at hand. For example, not long ago, as I was driving up a highway, a frantically flying crow cut across the road just ahead of me. Right above it was a small falcon that dropped down over the black bird and punched the crow with its foot, sending feathers flying. For me, it was a remarkable moment. There was something there that might become a finished drawing or even a sculpture. I let the idea cook as I watched for an exit where I could stop to make a quick sketch of what I wanted to remember.

At that point I wasn't concerned with details as much as I was with outlining the vitality of the two forms clashing overhead. A number 2 pencil and a pad of paper were the tools used to record some of the memory and excitement of what

Garter Snake, 1994
Black marble, 6 × 11 × 8 in.
Erupting from underfoot, a garter snake coils and slithers its way across my path into the salal that borders the woodland above McArdle Bay. As it weaves its body through the mire of branches, its hurried and polished-metal sleekness contrasts with the static stands of ground cover. I'm reminded of all the life I unknowingly pass over, unheeded by my sightless feet.

I'd witnessed. These shorthand sketches, along with thousands of others, are filed away as "note cards" for possible drawings and sculptures in the future.

DRAWING

The more disciplined process of studio drawing is sometimes necessary in refining the shapes and postures of my subjects. Here I can explore those unique and subtle details, attitudes, and moods that distinguish one subject from another. Drawing allows me to take the important impressions of my experience recorded in the sketch and give them greater emphasis, as in the "softness" of an owl's plumage, the "sleek and slippery" surface of a garter snake, or the "wetness" of salmon. Here I tease out those unique elements of design and appearance essential to conveying the "-ness" of my subject. The process always involves trial and error. I learned long ago that if I persist after failure, somewhere out ahead I'll likely get closer to the truth of what I am seeking to say. Talent is never realized without perseverance.

PEN AND INK

My first two books (*Birds of Prey* and *Owls*) were composed of pencil drawings, but all of my subsequent illustrations for books have been rendered in ink on scratchboard. I shifted to this medium as I found ink images to be far more bold and dramatic. Lacking halftones, an ink drawing is more a declaration than an explanation. To achieve this effect, I transfer the outline of an initial drawing onto the surface of the board. I then paint in the outlines in ink, and the details of the original pencil drawing are produced by using a sharp stylus to scratch through the dry ink into the white clay finish of the board. A very fine line of white is revealed, and eventually, using the stylus, I can produce the fine details, patterns, and highlights that are important in defining and giving vitality to my subject. As with stone carving, I'm removing the nonessentials to reveal the strongest forms.

The work of several naturalist artists has influenced and informed my pen-and-ink work. The Englishman Charles Tunnicliffe and the Americans Rockwell Kent and Lee Jaques achieved a level of artistic excellence that has set the standard I've sought to meet in my drawings. Superbly designed and executed with economy, their woodcuts and ink scratchboard compositions convey the power of landscapes and seascapes along with the spirit of life within them. The master painters and sculptors of the Edo were also exceptional in their evocative work that says more with less. In particular, the samurai swordsman, painter, poet, and carver Miyamoto Musashi achieved remarkable expression in a small body of work. His efficient use of his sword was equaled by his use of a brush.

STONE CARVING

Having a source of material to carve and access to fundamental tools to work
with made it easy to make the transition from drawing to carving. There were
ample amounts of steatite, chlorite, and marble along the edges of the upper
Skagit River, much of which could be carved. It was there, at public access
points where the river cuts across veins of metamorphic rock, that decent carv-

Falcon at Skagit Bay, 2007
Ink drawing, 7 × 5 in.
Looking out over the embayments of the Sound in winter rewards the eye with startling
back-lit silhouettes. Each has a story if we're willing to watch and listen.

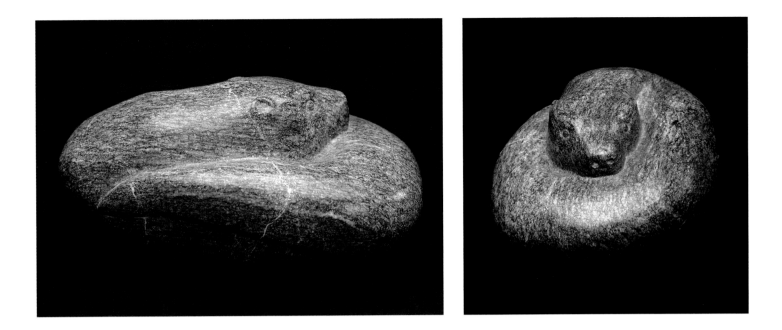

Coiled Otter, 2002
Granite, 8 × 12 × 14 in.
In a river stone I found an otter coiled up for warmth and comfort. My task was simply to remove the nonessentials.

ing stone could be found in abundance. Here, too, one could find odd boulders of marble that had been left by receding glaciers thousands of years ago and had tumbled into smooth, provocative shapes by the flow of water over the riverbed.

In the summers of the late 1960s and early '70s, friends and I would make monthly day trips from Seattle to extract stone from the banks of the upper Skagit. Packing a big lunch, a bottle of wine, a shovel, and a pry bar, we would make a picnic out of the occasion. One trip in particular was a memorable one. It was late afternoon, and my friend David Munsell and I had already spent several hours loading the back of his aged pickup with more than a thousand pounds of stone when we spotted a glistening piece of chlorite near the river's edge. The afternoon sun lit up its slick, black, river-wet back, giving it the appearance of a beast rearing up out of the water. We were tired, and getting this massive piece up sixty feet of embankment would not be easy. Still, its superb uniformity and color were enough to recharge us with adrenaline, and we set about wading into the swirling shallows to dig the monster out of the muck.

Like an iceberg, most of the stone was below the waterline, and over the next four hours my partner and I went through our Sysiphisian labor, pushing, prying, and rolling what I judged to be four hundred pounds of chlorite up the clay gumbo embankment. For every yard gained we fell back a foot. By the time the

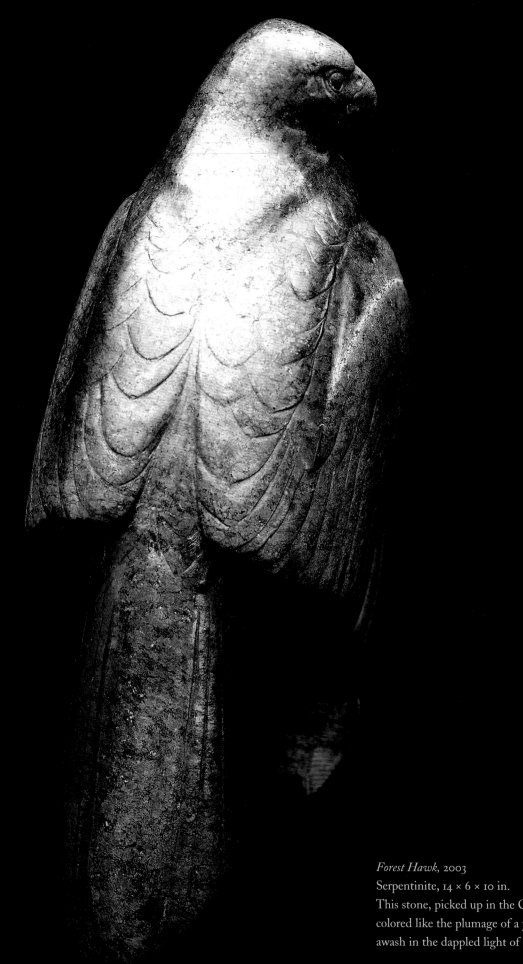

Forest Hawk, 2003
Serpentinite, 14 × 6 × 10 in.
This stone, picked up in the Cascades, is
colored like the plumage of a young hawk,
awash in the dappled light of the deep forest.

stone was hefted onto the truck, darkness was upon us. Slathered in mud, we had hardly gotten underway when it was clear that the truck was suffering from some serious steering problems. The front end of our vehicle was being lifted up by the added weight in the back, leaving little purchase for the front tires on the road. Our headlights, rather than being directed down the highway, shot up into the top edges of the bordering forest. To continue would be disastrous. Another hour was spent jettisoning stone and shifting the load before we could get safely underway. Once delivered to my studio and examined, the piece of chlorite, which had looked so promising, gave me no indication of what it might become. Over the next year the stone kept its secrets, remaining aloof and distant, awaiting the time that my experience and emotions would help me discover them.

At about this time I was writing a book on the North American crow and raven family. My immersion in the natural history and myth of the raven in particular would make a significant difference in how this great stone would fulfill itself as a sculpture. In connection with my research, I had made the acquaintance of a graduate student anthropologist who was working at the Museum of

Tlingit Oystercatcher Rattle, 1982
Ink drawing, 20 × 17 in.
Few carvers have distilled the essence of an animal's spirit into a cultural art object more profoundly than have the native artists of the Pacific Northwest.

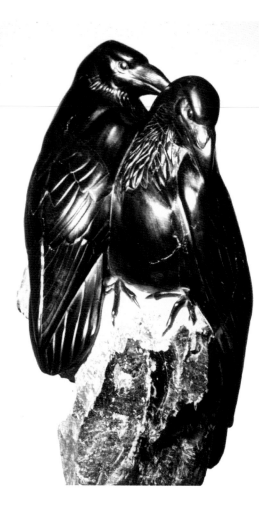

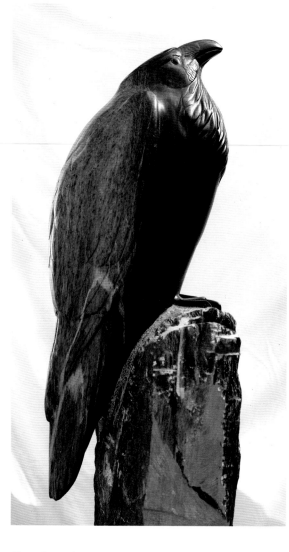

Courting Ravens, 1978
Chlorite, 30 × 20 × 15 in.
Some birds, like people, can be very demonstrative in expressing affection toward one another. While writing a book on the crow and raven family, I was immersed in ideas, emotions, and images all relating to these birds. I'm certain it was because of this singular focus that I suddenly saw a pair of courting ravens in what up to that moment had been an undefined slab of carving stone with no particular future.

Transformation, 1987
Serpentinite, 28 × 10 × 10 in.
Native people of the Pacific Northwest have imbued the raven with a repertoire of extraordinary capacities. Creator and trickster, Raven is a mythic transformer capable of changing himself from one being into another. When polishing this stone, I discovered that my raven seemed to be in a state of "transformation." The soft and subtle green of the bird's tail and wing give way to the hardened blackness of its chest, head, and beak.

Anthropology in Vancouver, British Columbia. Her passion for ravens was equal to mine. She suggested I visit the collections at the museum, as she thought I would find superb examples of native art depicting the mythic Raven. She was correct. My visit there was an emotional one. I remember feeling haunted as I wandered the halls with their displays of raven masks, rattles, stone bowls, and painted boxes done in the style and vitality of the Tlingit, Tsimshian, Kwakiutl,

and Haida artists. These native carvers and painters had translated the raven's spirit into forms that were bursting with energy. Not unlike the Edo artists, their economy of line emphasized the most powerful elements of the subject.

Coming home later that evening in a state of emotional turbulence, my headlights lit the edges of the river stone and it came alive. I could see a pair of light-etched ravens waiting to be defined, one bird arched above the other in a caress of courtship, their heads and beaks clearly defined. That night I dreamed further of this pair of birds, imagining them from every angle. The following morning I set to work with an understanding and passionate momentum that made my task seem easy. In five ten-hour days I finished the piece. As I write this today it seems impossible that I could have completed the work so quickly. Something of that scale today would require months of work.

SOURCES OF STONE

When I first started my career, suppliers of carving stone were very rare. Over the past twenty years, however, as more artists have come into the field, stone has become easier to obtain. Sometimes I placed orders directly with stone brokers in Italy. I recall starting my first conversation with a few phrases of tortured Italian only to receive a reply, "Hey, buddy, relax! How much stone do you need?" To get a good price, I would order tons of black-and-white marble, and it would arrive months later at Seattle's waterfront. I remember the thrill of bringing in marble from the very quarry where Michelangelo, Cellini, and Canova selected their material. In fact, I got carried away as order after order arrived. Soon the entry of my studio looked like I was more the stone supplier than the carver. Flats of stone were arriving faster than I could carve them. To this day, some of it remains waiting to be shaped.

Some of my carveable stone comes to me by chance and circumstance. A luminous piece of jade shaped like a brick and probably used as a doorstop was kindly offered by a gentleman who knew of my sculpting work. Within a moment or two of handling the jade piece, I could see a brooding nighthawk. There it was, settled in on a ledge below a tree canopy and bathed in green light. Once I noticed that a row of stones being used as a divider in a parking lot included some lovely pieces of green chlorite. Removing a few without disturbing the designation for the orderly parking of cars, I was able to secure individual stones that would later become a pair of fledgling owls and a merganser swimming in pursuit of a fish.

Among my most serendipitous discoveries of carving material involved a trashed pool table dumped on the roadside. Driving by it, I noticed that the felt had been torn away from the table's top, revealing the beauteous surface of one of the slate plates. Making a quick trip to my studio, I returned with tools

sufficient to dismantle the table and remove the three great slabs of flat stone that together weighed nearly five hundred pounds. I had the slate for a year or so before I thought seriously about drawing on it like a sheet of paper and then carving those renderings into relief. One of the complete panels has become a work entitled *Raven's Wall*.

Hare, 1986
Marble, 5 × 7 × 5 in.
In the early part of the twentieth century, European rabbits and Belgian hares were raised on San Juan Island for the commercial meat market. The enterprise never really took off, so many of the captive animals were released into the wild, where they thrived and multiplied. It wasn't long before eagles, hawks, and great horned owls responded to this abundance of prey, and their numbers increased too. To this day, these introduced hares and rabbits are part of the diet of good numbers of eagles, hawks, and great horned owls on San Juan Island.

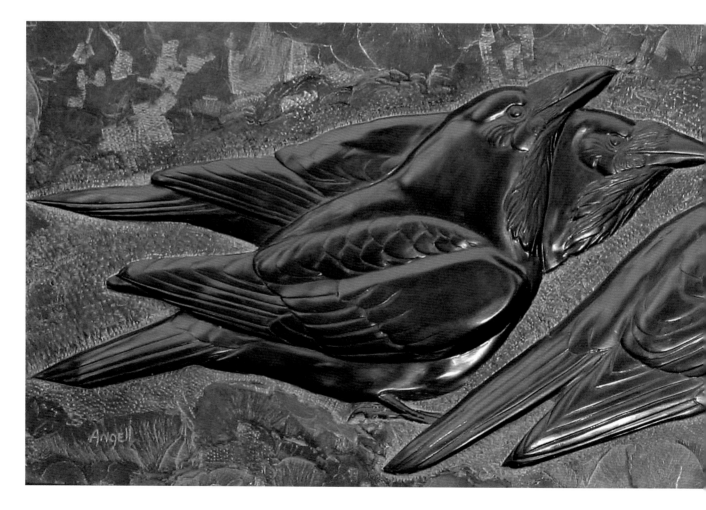

THE SOUND AND RESISTANCE OF STONE

Each type of carving stone has a sound to it that tells me something of its composition and continuity. When I began, it took me a while to understand that the "rattle" in the stone heard when I struck it with my hammer was an indication of an unseen flaw within. Conversely, when the material is struck and it "rings," it can be assumed to have uniformity and strength. Now well before I put saw and chisel to work, I strike the stone and listen to its "voice." What I hear will determine how I will proceed—if at all.

After more than forty years, I still enjoy the resistance the stone provides

Raven's Wall Panel, 2006
Slate, 20 × 48 × 1 in.
Ravens at various times of the year are very gregarious. In Puget Sound country where thermals rise from the heated faces of cliffs, they gather to socialize and play in the heavens. This piece was carved across the face of a piece of slate that was salvaged from a discarded pool table.

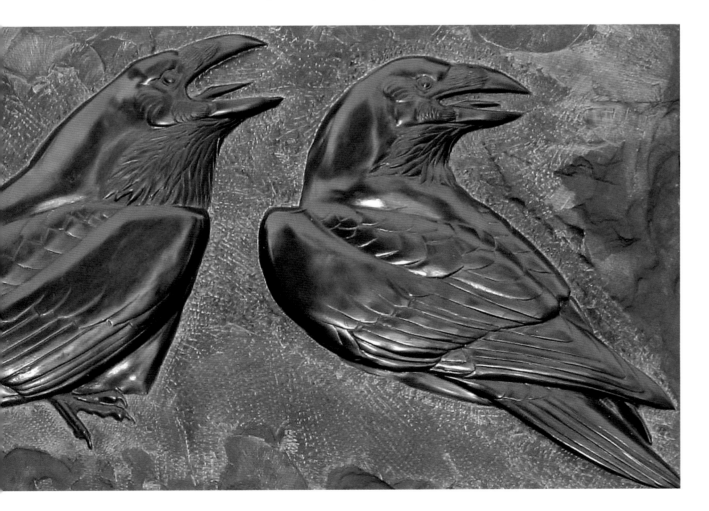

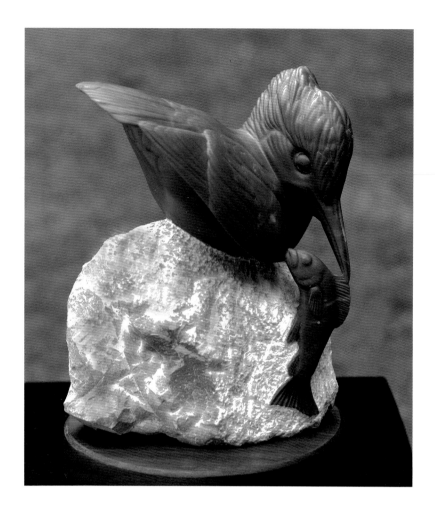

Fish Catcher/Kingfisher, 1986
Marble, 8 × 6 × 4 in.
When a stone's shape and color are both a match for a subject, I go with what comes to mind. The kingfisher-gray of the marble caught my interest, and the unusual extension of one side of the stone hinted at the bird's beak and what it might hold in it. The marble, while a relatively hard and capable stone, wasn't strong enough to suspend a fish. My challenge was to shape the bird's catch to be supported within the stone and in a manner that the beak, fish, and surface all seemed naturally related.

when I carve it. "Try to move or shape me," it seems to say. Some of my satisfaction comes from knowing that something initially so unyielding can be "coaxed" into revealing the forms, patterns, and colors within it. While sketching and drawing have provided a foundation for understanding my subject, carving brings it into my senses to a far greater degree. Now I can witness the moment from innumerable points of view and feel the form under my hands, remembering my time in the field with it, and imagine its movements in life.

Every stone possesses virtues, but the harder stones—black marble, basalt, granite, and jade—are for me the most rewarding. They take a finer line, polish to a richer finish, and often possess a translucence that gives a greater depth to the form's color and pattern.

I've worked in steatite, chlorite, limestone, alabaster, sandstone, slate, marble, serpentine, granite, basalt, and jade and found something virtuous in them all. When I began my carving career, I discovered that the softer steatite yielded forms quickly, requiring little more than a wood chisel and rasp. Alabaster was nearly as easy to shape. Harder stones, however, require more specialized tools but are far more rewarding in what can ultimately be shaped and finished. The likes of black marble and basalt take a fine line and polish to a rich luster. Jade and basalt require diamond tools and are in a class by themselves in possessing a luster and warmth that bring a piece to near life.

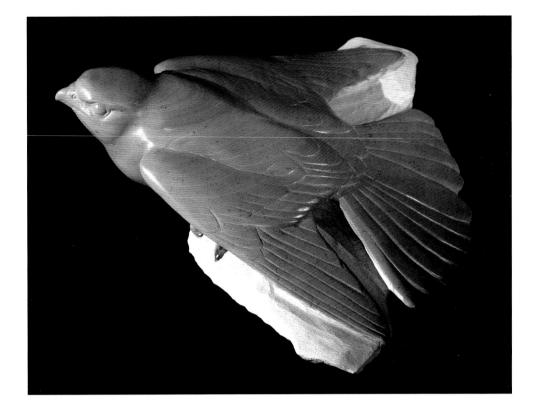

Falcon on Cliff Ledge, 2005

Marble, 6.5 × 15 × 15 in.

Like humans, other species enjoy a respite from the rigors of meeting the day-to-day requirements of just staying alive. In a moment in the sun, the falcon stretches her wings to feel the lift beneath them that the warm breeze provides. The subtle pattern of layering in the marble, set down and configured over millions of years, suggests the bird's plumage over its back and wings. I am in absolute awe of these cohorts, whose lives depend, day after day, on their skills as hunters.

Indomitable, 1988

Marble, 5 × 14 × 6 in.

There was a time when sadness affected my work and the shapes I saw were all injured or defeated. I began shaping a marble piece of a wounded hawk, and I think it was something of a self-portrait at the time. Then, not so much from conscious intent but rather from what I began to feel generally, the bird's wing was raised in defense and its foot positioned not in collapse but in preparation to stand. This carving had become my metaphor for recovery.

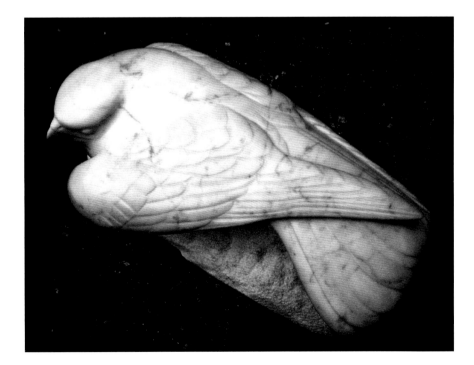

THE PROCESS: FINDING FORM IN A STONE

My carver friend, the late Melvin Olana, from Shishmaref, a settlement on the Arctic Ocean, was a master carver at finding forms in the material at hand. Turning a piece of whale bone, walrus ivory, caribou antler, or stone over in his hands, he looked for familiar shapes to emerge. I believe that his life in the open landscape of the far north had finely honed his ability to seek out and identify the most subtle bits of information that would lead him to see shapes in whatever he looked at. He could find the wings of an owl in the flare of a whale's vertebra or fashion a miniature dogsled from a mammal's jawbone. In a stone he looked for movement in its pattern or shape, and with a hammer and chisel soon had a loping bear underway. He showed by example that with thoughtful deliberation the artist could let the material take him on a creative adventure.

It could be the economy of effort that led to maximum effect. More than once Mel invited me to join him during his summer stays in the Arctic, telling me that we would see extraordinary numbers of the animals we both loved to carve. I kidded him once, saying that I thought his invitation was a plot to take me into the treeless tundra and leave me there, thereby eliminating his competition. Without missing a beat, Mel responded in mock seriousness, "Oh no, Tony. I would leave the Fish and Wildlife guy, but not you. I like your work too much."

My carving is very direct. I consider the stone's shape, size, and color, as well as its relative hardness. Most important, I bring to the stone my experience and look for familiar shapes and actions that might match the profile of the material. To clarify this carving process, an example is in order. A two-hundred-pound piece of statuario marble in my studio has caught my eye. The stone has an thrust in its form that extends like a bird's wing. I begin to imagine the rest of the bird beneath this extension—a falcon perhaps. Walking around the marble, I apply my memory of what I've seen, check my notes and sketches, and look for a match to the material's color and shape.

These final polishings reveal surprises of color and pattern that match the subject in remarkable ways. Basalt from the Cascades can be brought to a smoky black glass finish with flecks of gold color and iron oxide stains. Jade finishes to appear like the surface of a dark pond with intriguing shapes suspended below.

Years ago, upon finishing a carving of a puffin in green chlorite, I was astounded to find an orange-colored vein in the material that ran like a tear down the cheek of the bird. This line of color revealed in the stone was even more remarkable because the work was finished not long after the death of a beloved friend, Florence Jaques, the wife of Frances Lee Jaques and also a friend and mentor. A writer, Florence had composed what would become a familiar children's poem, "There Once Was a Puffin," years earlier, and I had put the

Carving Tools, 1994
Ink drawing, 10 × 8 in.
From the very beginning, three basic tools have remained essential to the stone carver: a hammer, a sharp chisel, and an abrasive rasp for shaping the liberated form.

The stone.
Marble, 30 × 18 × 6 in.
I see a falcon in the stone, cutting into the wind in pursuit of waterfowl along some stretch of shoreline on the Sound.

Drawing of falcon in the stone.
I outline the shape of the stone on a sheet of paper
and then describe a flying falcon within it.

Outline of falcon on stone.
The form of the drawing is then copied onto
the stone using a grease pencil.

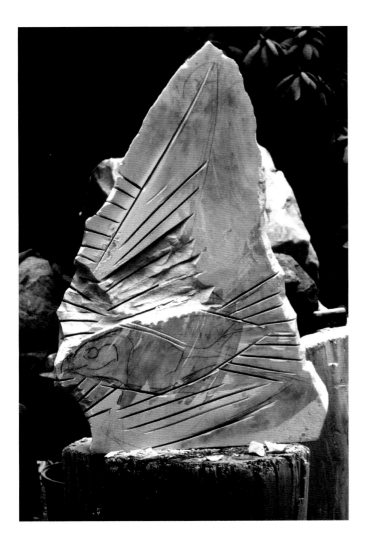

Cutting into the marble.
With the outline completed, I use a masonry saw to make parallel cuts in the marble just short of the outlined falcon.

Use of hammer and chisel.
With a hand chisel, I begin to chip off the material between the cuts along the edge of one wing, taking the surface down to the shape of the figure. This process is repeated again and again until the broad outlines of the bird have been roughed out.

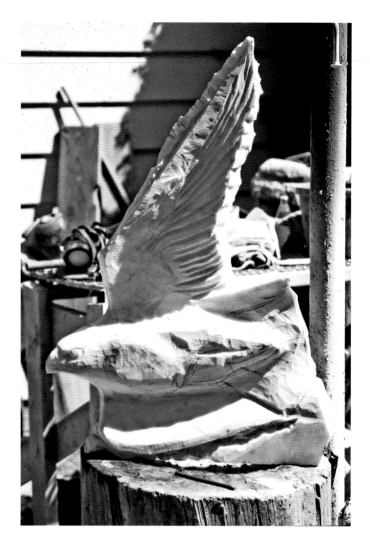

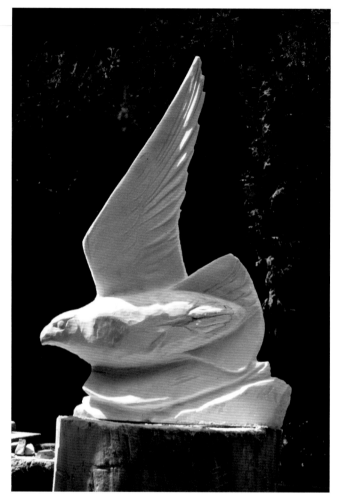

Shaping falcon with grinder.

Once the basic form has been developed, I apply an angle grinder with a fine stone head. Slowly the marble is sanded down, bringing out the more subtle contours of the falcon. Throughout the process, I continue to draw on the surface of the stone. Each time I'm adding further details, giving patterns within the general shape of the feet, wings, and tail. The careful application of the edge of the grinder is essential in initially defining some of these lines.

Falcon shaped with hand-finishing tools.

When the falcon has been shaped in the stone, I refine and sharpen the patterns in the bird's design with files and hand chisels. Under the edges of the chisels, this dense yet responsive marble shaves away, leaving well-delineated, clean lines. I give particular attention to developing the eyes, as they seem so important in emphasizing the character of this subject. Equal effort is applied to the wings and feet by keeping an intimate grip on the hand tools so that they might be used as extensions of my fingers. Symmetry is important. While I'm not seeking exact replication of my subject, the lines of the eye and beak and the bird's overall structure should appear authentic and in alignment. Only then can my feelings prevail in my interpretation.

The finished *Falcon into Flight*, 1986
Marble, 30 × 18 × 6 in.

The finishing stage of a carving involves the use of carbide-coated abrasive paper with water to lightly sand the entire form. I'm always seeking to make my contact with the stone's surface as intimate as possible. The paper is folded over and held between my fingers so I can heighten and polish important convex and concave portions of the sculpture. I can clearly define the corner of an eye and straighten the fine, elongated line of a feather. With the paper in the palms of both hands, I can follow the curve of wings and bring their surfaces to a heightened sheen. During this process a range of polishing paper is used, from moderately coarse to very fine. With each successive rubbing out of fine abrasions and compressions in the marble, a new level of the stone's luster emerges. When the sanding is completed, the entire stone is given several coats of wax. Each application is polished out to reveal even more of the marble's inherent color. In the case of the gyrfalcon, the marble's warm cream colors are an ideal match for the whitest forms of these energetic birds.

poem to music and sung it for Florence and Lee when I first met them on a trip east as a young man. There is a particular line from that poem that immediately came to mind when that golden tear was revealed:

But this poor little Puffin,
He couldn't play nothin',
For he hadn't anybody
To
 Play
 With
 At all,
So he sat on his island,
And he cried for a while, and
He felt very lonely,
And he
 Felt
 Very
 Small.

—*Florence Page Jaques, "There Once Was a Puffin"*

THE TIME BEHIND THE WORK

I'm sometimes asked how long it has taken me to carve a particular piece. The sculpture *Falcon into Flight*, described above, required about three months of carving and added up to several hundred hours of time. I spent over half a year carving a pair of trumpeter swans. What aren't included in my answers are the countless hours spent preparing for the artistic interpretation of any animal subject. Thousands of hours of experience have influenced what I do as a sculptor. The enjoyable days in the field with my subjects, spent observing and sketching, are all preliminary and essential to what I can ultimately say in my work. All of the senses can selectively absorb impressions of the subject. At the studio, the artist distills from the experience something original and authentic. Emotions are a critical part of my work. Without the passions that motivate me to take chances in what I do, my work would never satisfy me or enjoy distinction.

Failure and occasional disaster may influence the time a particular work requires, and often such events provide insight and a more realistic perspective on my work. Even a well-planned piece can involve dead ends where, in spite of my best efforts to anticipate the material's strengths and weaknesses, it suddenly breaks away and I must start anew or abandon the work.

One unforeseen event that interrupted my progress still stands alone in its

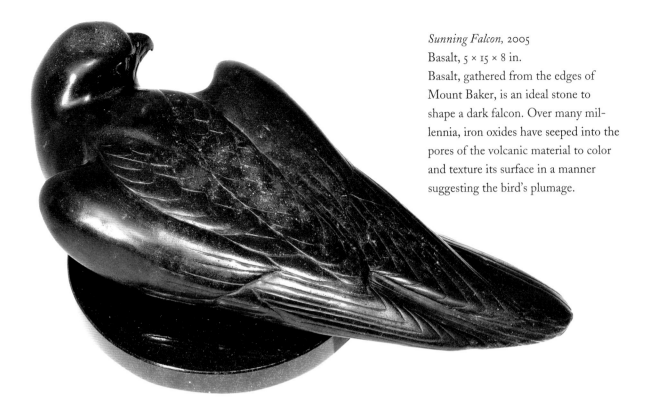

Sunning Falcon, 2005
Basalt, 5 × 15 × 8 in.
Basalt, gathered from the edges of
Mount Baker, is an ideal stone to
shape a dark falcon. Over many mil-
lennia, iron oxides have seeped into the
pores of the volcanic material to color
and texture its surface in a manner
suggesting the bird's plumage.

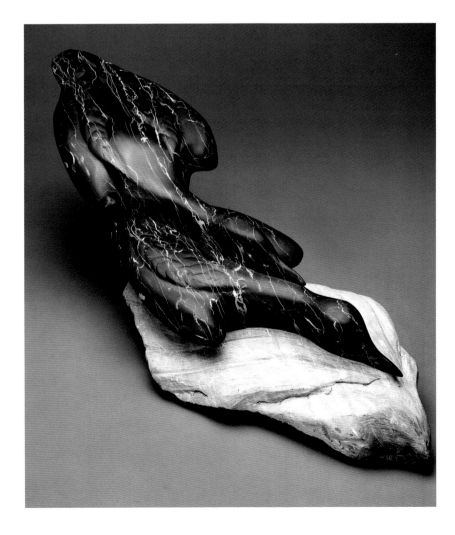

Racing Seabirds/Loons, 1982
Marble, 15 × 30 × 12 in.
Serendipity plays a large part in
my work. Something unanticipated
occurs that makes the sculpture much
more than what I had expected. It
could be a shape that emerges as
I work the stone or a pattern of color
that matches the moment imagined.
Such is the case with this piece. From
the far end of an abandoned pier,
I caught a glimpse of loons pursuing
one another underwater. I thought
that my impressions of their elongated
bodies in tight formation might be
realized in a piece of marble I had in
my studio. The stone did match the
configuration of the moving forms,
but what astounded me was how
perfectly the patterns in the material
mimicked the play of sunlight over
the bodies of the submerged birds.

Tufted Puffin, 1972
Steatite, 10 × 8 × 5 in.
As I polished this piece, I was
astounded to discover that a line
of color ran like a tear down from
the eye of the bird.

uniqueness. Watching common terns resting on beaches along Hood Canal one fall, I was struck by the elegant manner in which they displayed their wings as they stretched them overhead. I had a piece of alabaster that I thought might be a perfect match for designing a carving in a way that a pair of wings could touch at the wrist over the bird's body and appear naturally connected. Such a tiny bridge of stone between the bird's wrists would provide the support needed to elevate the stone wings well above the body. I could see in the alabaster a stretching tern nearly formed.

Returning to my studio, I cut away a few pieces of the soft alabaster with a masonry saw and then shaped the wings with a coarse rasp. With a half day's work, I had roughly fashioned a small tern with its wings reaching out into the space over its back. This was one of those carvings that had come to near-realization so quickly that I felt I had to stand back from it and contain my excitement in fear I might overwhelm what I accomplished if I kept working. To settle down, I left the sculpture on the face of a broad round of cedar that I found ideal for carving on. Walking away, I looked back to see the translucent alabaster wings aglow in the sunlight. They seemed alive.

I took fifteen minutes to walk along the creek that borders our home, experiencing the pleasure that comes when I feel I'm on the verge of creating something unique and exciting. When I had settled down, I returned to the studio by a different path in anticipation of catching a different view of the sculpture that might instruct me further on how to finish it. Looking around the corner of a screen of rhododendrons, however, I found that the tern had disappeared. Dumbfounded and desperate, I first wondered if someone had taken it. I raced onto the deck where I worked, and as I did, I caught a glimpse of the neighbor's cat rounding the corner of the studio buildings. I found the tern on the other side of the cedar round, now broken and shattered, the result of the cat's attack. I buried the pieces, finding no consolation in the feline flattery paid to my creation.

My time spent with my subjects has also involved direct handling of them. Given today's regulations on keeping wild animals, it was fortunate for me that as a child there were few such restrictions, and I was able to try my hand at taxidermy. Taking a correspondence course in this practice in the late 1940s provided me with a constructive outlet for my curiosity about birds, mammals, and reptiles. For a dollar each I received a set of ten lessons from J. W. Ellgood's School of Taxidermy, headquartered in Omaha, Nebraska. By the time I completed the series, I had information sufficient to preserve anything, from a butterfly to a bear. This interest in exotic chemical concoctions for tanning hides, my skill at stitching, and my entrepreneurial efforts in charging fifty cents

Common Tern, 1979
Alabaster, 4 × 12 × 5 in.
In spring and fall, migrating common terns move through Puget Sound to fish the channels and straits of the San Juans and to rest on the sand beaches of Hood Canal and Dungeness Spit. The cream color of alabaster is a suitable match for portions of their plumage.

to prepare hunting trophies for friends convinced my mother that there might be a future emerging from these boyhood interests. She was correct, but only later did she see their relationship to my art. I think initially she expected me to become an undertaker.

Practicing taxidermy transferred a wealth of information to my fingers and hands. That tactile familiarity provides some of the basis of understanding what's beneath the skin of my subjects, how their shapes actually feel, and the manner in which their bodies articulate. There is synesthesia at work here. What I feel in my hands as a sense impression complements what I'm seeking visually. If it feels right, the form is closer to the truth I am seeking. As one sense informs the other, I believe I can take the feeling of a winter's chill and the sounds of a south wind blowing hard off the icy straits and let it influence my sculpted memory of a snowy owl surveying the frozen landscape.

Living with wild creatures creates a special intimacy. I was able to rehabilitate many birds and small mammals long before a blizzard of permits were required to do so. Short-eared, barn, barred, great horned, snowy, screech, saw-whet, flammulated, and pygmy owls have all lived in my house for varying periods of time. These were injured birds and most were rehabilitated and released back to the wild. A pygmy owl once had the "run" of my house and would fly from room to room and down hallways, stirring up the air at all hours. He would be perched on the back of the furniture or on top of the curtains when guests or neighbors came by. Many assumed that the diminutive bird was an ornament of some sort until he bobbed his head, fixed them with a glare from his bright

Snowy Owl, 1974
Alabaster, 15 × 14 × 10 in.
Puget Sound shores periodically host wintering snowy owls. The birds appear to be wedges of light set into the darkness of plowed fields or to look like white lights atop drift logs piled high on the shore by storms. When prey is scarce in the Arctic, snowy owls migrate south to winter here on the Sound.

lemon-colored eyes, and flew with a gun burst of energy over their heads and out of the room.

Small mammals too were occasionally in residence, including a Douglas squirrel, an opossum, a red fox, a mountain beaver, and a raccoon. The raccoon had been found as a youngster on the side of the road during a cross-country

Hunting Owl, 2005
Marble, 6 × 7 × 5 in.
Some of our Puget Sound woods teem with nocturnal life, but, rarely exploring them, we know little of it. So silently do they prowl their arboreal corridors that we only infrequently see saw-whet, screech, barred, barn, or great horned owls. Like so many of our cohorts here, the owls' importance in the living fabric of Puget Sound goes unappreciated. Without their hunting of a wide range of insects, birds, and small mammals, the current equilibrium of our ecological systems would be dramatically altered. The sawwhet owl's size, plumage color, and pattern was a fine match for the stone on hand.

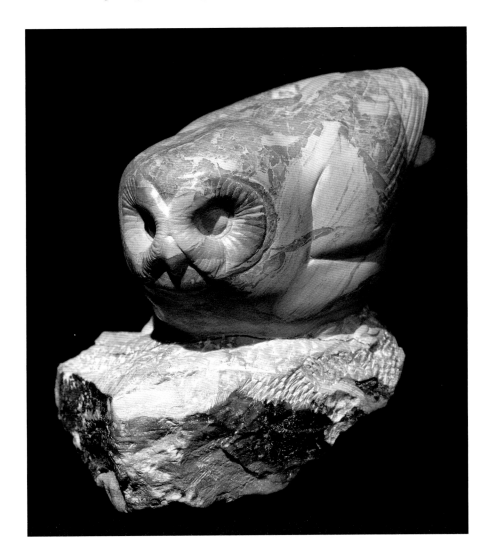

GOOD FREND FOR IESVS SAKE FORBEARE
TO DIGG THE DVST ENCLOASED HEARE
BLESE BE Y MAN Y SPARES HES STONES
AND CVRST BE HE Y MOVES MY BONES.

Pygmy Owl, 2007

Ink drawing, 7 × 10 in.

Many years ago, a pygmy owl lived with me for a few weeks, having the run of my house. That intimate exposure left such strong impressions of this little owl's spirit and strength that I have continued to interpret its form and personality in line and sculpture to this day. Even using a single subject (Monet had his water lilies), the opportunities for artistic interpretation are infinite.

trip and brought all the way back to Washington to live with us. Suffering from a bowel disorder, he would curl up under our living room couch and produce some extraordinary sounds. When we had company, these explosive "releases" were followed by a period of awkward silence and then expansive explanations. If there is a positive side to all this, it is that social gatherings at our home have never lacked for interesting topics of conversation.

Flying falcons and hawks in my youth left me with poignant memories of their character and vitality. My many years in the company of ravens, however, have probably had the greatest influence on my work, predisposing me to see the possibility of interpreting my feelings for them in almost any material I work in. All of these associations have given me a heightened appreciation of the spirit, intelligence, and dignity possessed by these fellow creatures.

When the creative juices are flowing and the stone fragments are flying, I may have four or five pieces underway at any given time. I'll go from one to another as my motivation, inspiration, and energy level allows. Even when well underway with a project, I may be seized with what seems to be a better idea that requires putting everything else aside to pursue it. And, of course, as in the aforementioned *Courting Ravens,* there are occasional times when I'm simply unable to read the stone and must walk away, to return for another try weeks or even years later. A chanced view of the material standing on the sculpting block will combine with a stored memory and provide the fresh perspective that tells me what's within.

Gazing Merlin, 1989
Slate, 12 × 6 × 5 in.
For many years I kept a black merlin that had
been severely injured by some mindless shooter.
Never did she lose her disdain for the species that
had harmed her, yet to the end she maintained
her beauty and indomitable spirit. Sometimes
I watched her from a distance gazing skyward
as if in memory of her days aloft.

It is a strange compulsion
this putting metal to stone

I believe there is the quest
for permanence and pleasure
in pitting muscle against resistance.

I believe there is that insane challenge
of drawing something forth from
the unknown and feeling the radiance
of surfaces textured and smooth.

I believe there is the romance
with this most ancient of traditions
and the sense that I clasp hands
with departed spirits.

I believe there is a meeting with
other life
and a renewing of the kinship we share.

It is the composition of all of these
that comes together
in the music of the stone.

The chisel plays over the surface
and rings out a message
that is finally clear when the last fragment
spins into the night air
singing of what it has left behind.

—Tony Angell

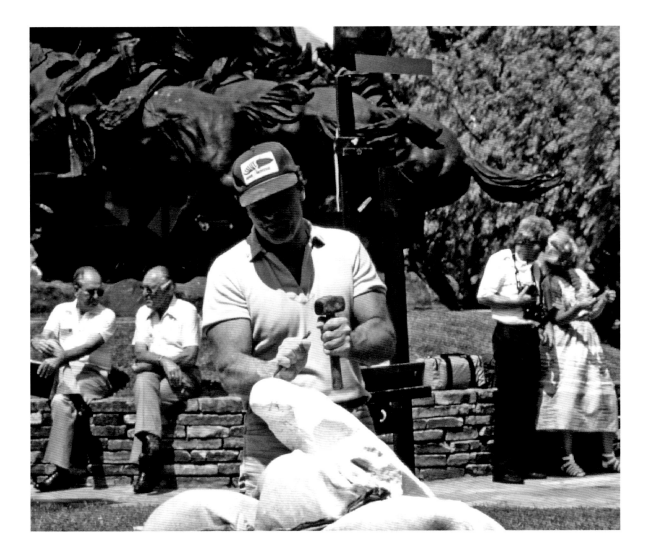

The artist giving a carving demonstration at the National Academy of Western Art show in Oklahoma City, Oklahoma, 1983. As one can see by the attention given the artist, the process of carving stone is, for the observer, a riveting one.

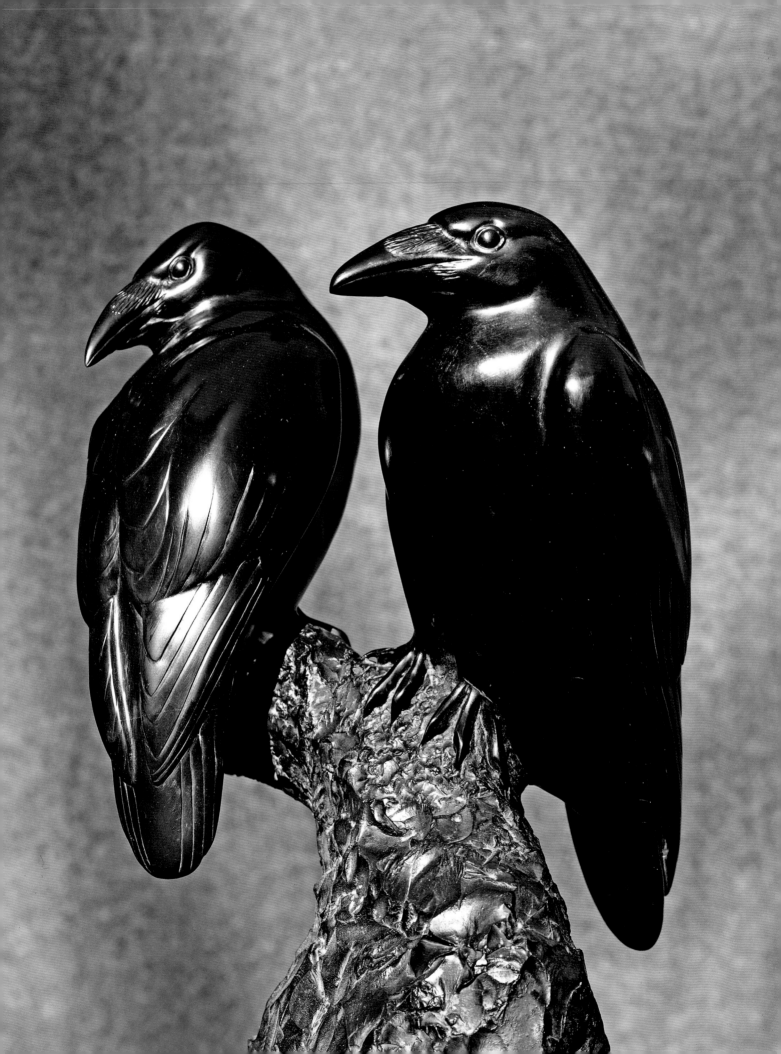

GETTING INTO NATURE

You will see the Way in everything.

—MIYAMOTO MUSASHI, *A BOOK OF FIVE RINGS*

We are the people of technology and convenience. We're increasingly enveloped in a world that separates and isolates us from any continuous intimacy with nature. I'm certain, however, that within most of us there lingers a subconscious longing to revisit and renew bonds with the natural world, as they are indispensable to our welfare. Throughout most of human history we have shaped and adjusted our behaviors, respectful of the forces of nature. Our age is no different. At our door is the vastness of Puget Sound. A cherished portion of what was originally present before the age of industrialization still remains to us, and much of what has been degraded and threatened is still suitable for restoration and stewardship. This is one of those sacred places where we can find renewal and wisdom.

Over the half century I've lived in and explored Puget Sound, spending time in those places that retain some element of the wild Pacific Northwest has been essential to my art and well-being. Each visit rekindles the creative fire. Each period, no matter how brief, stirs the imagination into fresh possibilities and deeper understanding.

It has never been enough to "see" my subject; I must share time with it in the wild. Catching a glimpse of an assemblage of snowy owls is not really knowing

Crows Watching, 1996
Black marble, 16 × 14 × 8 in.
Walk out among crows and you'll soon feel their gaze. They watch us and read our body language to determine our intent. Are we fearful, indifferent, or do we intend them harm? The dramatic increase in their populations here shows clearly that, unlike other more specialized species, crows have exploited the changes we've made to the landscape.

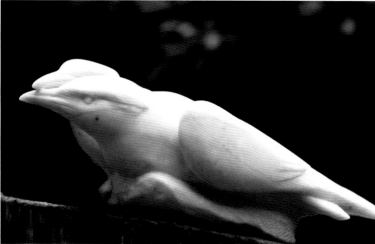

Caspian Tern Courtship, 1980
Alabaster, 4 × 16 × 8 in.
Caspian terns have expanded their range from our outer coasts to the Strait of Juan de Fuca and have wandered into the interior of Puget Sound. Their raspy voices are heard over Lake Washington and in Skagit Bay, and a colony exists at the edge of Dungeness Spit. When pairs court or squabble with other birds on their nesting grounds, their ritualized animations are graceful and intriguing.

them. If I'm going to genuinely interpret my subject in line or stone, I've got to settle into the place the animal is a part of. I have found that by retreating into cover and watching from a distance, whatever I'm observing has time to adjust to my presence—or, better yet, lose interest in me. When the latter happens, a wild animal is unrestrained by any worry or distraction caused by human presence. It's free to hunt, court, brood, squabble, bathe, groom, and even nap. When I remain unseen or unheeded, my opportunities to observe the lovely repertoire of behaviors and respond to them artistically expand dramatically.

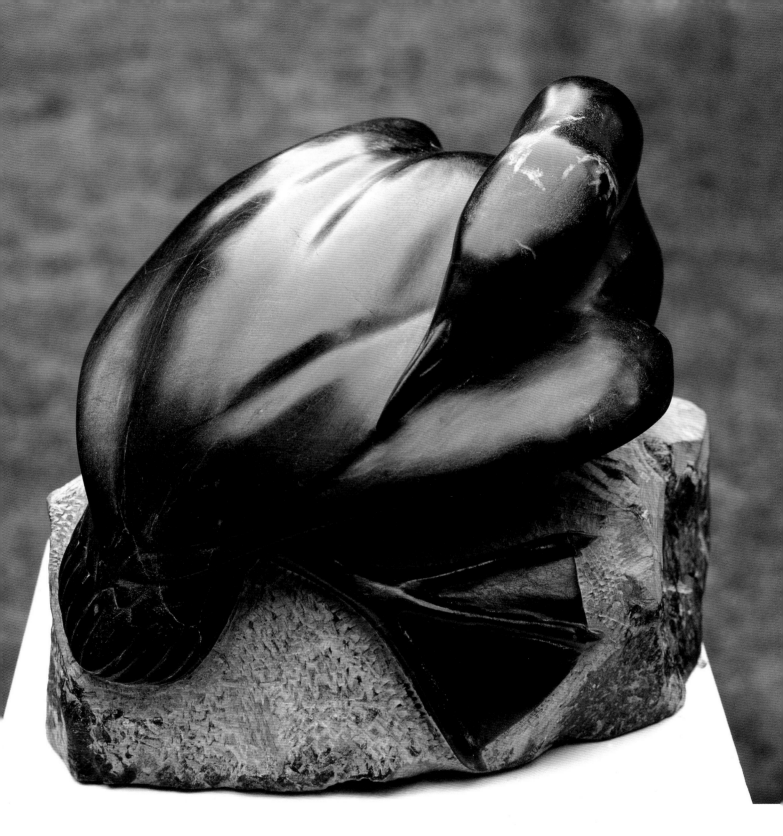

Preening Loon, 1979

Chlorite, 12 × 12 × 10 in.

Many years ago I held a dying loon in my hands. She had been found on a beach, a casualty of an oil spill here in the Sound. Even near death her muscled chest seemed full and powerful, and I imagined the thousands of miles she had traveled on the wing over her lifetime. Her soft blue-white feet with their enormous webbed toes closed over the back of my hand, still seeking to push off and escape her fate. Those memories remained to me as I carved the bird back into life a decade later.

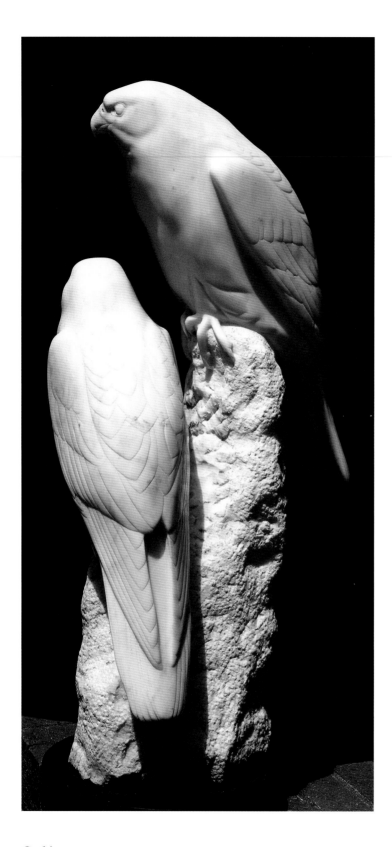

Gyrfalcons, 1999
Marble, 38 × 18 × 10 in.
Although most of the wintering falcons on Puget Sound appear here as solitary winter
residents, a few pair up for their return flights to their nesting territories in the Arctic.

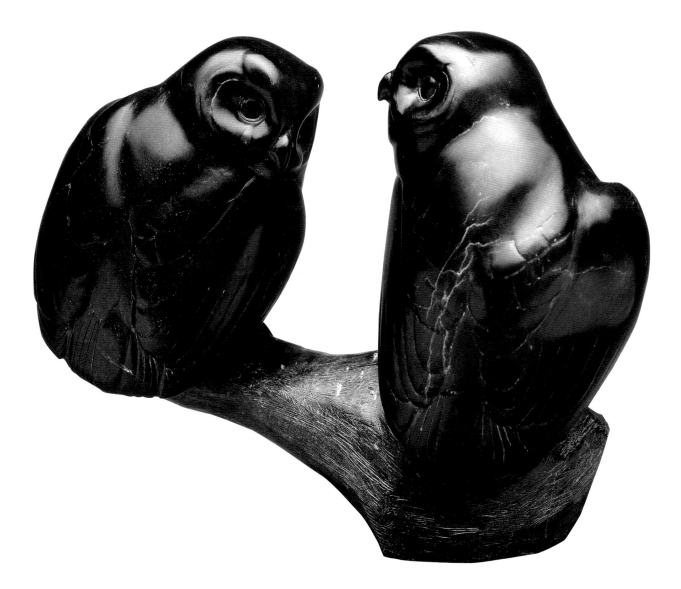

Screech Owlets, 2000
Chlorite, 8 × 10 × 5 in.
Our riparian woods within Greater Puget Sound have long provided habitat for the
Western screech owl. Their soft hoots and trills are familiar night music, particularly in
late winter and early spring. When the young fledge, they remain together for several
weeks and roost near their nest hollow, which is often an abandoned flicker cavity.

I now rarely think of my subjects as solitary forms. They are more than
single portraits; rather they are active beings animated by one another and by
their engagement with the world. I find that abstract concepts like "kinship,"
"nurturing," "bonding," "fledging," and "competition" become tangible in work
that involves pairs and groups of animals. These active arrangements extend
my opportunity to explore and emphasize the beauty inherent in the shapes and

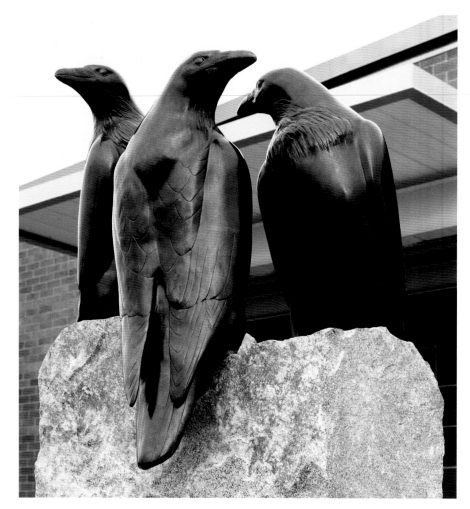

Wisdom Seekers, 1998
Bronze and granite,
11 × 4 × 2.5 ft.
Native people throughout the northern hemisphere have incorporated ravens into their cultural myths and traditions. Long before animal behaviorists confirmed that these species are remarkably intelligent, anyone who lived with these birds for a period of time quickly recognized their clever and insightful nature. Ravens learn from watching their world and one another and seemed a fitting metaphor in sculpture at the entryway to the library in Redmond, Washington.

lines of my subjects and how the juxtaposition of one form with another creates an entirely fresh aesthetic design. The fluid beauty of trumpeter swans can be made even more apparent by pairing these birds, as each interpretation can reveal something unique. Carving or casting a flock of flying birds, if done convincingly, heightens the feeling of the flock's momentum and of the synchrony required for such flight. Here again, designing the subject in numbers rather than in a single study creates a greater impression.

While I relish the unexpected when I visit natural areas on the waters of the Sound, I do so with some degree of expectation. The time of year, the tides, the hour, and, of course, the particular habitat I visit will all determine what's likely to be found. At the Nisqually Delta and estuary in the winter, I arrive with some "search images" of what I might expect to see: shorebirds beyond the dyke or otters fishing in McAllister Creek. Although I'm "taking" only impressions, I'm like a hunter of any species, as I have in mind what I'm looking for and I'm not overwhelmed or distracted by everything that I see. Of course, there is always the surprise of something unanticipated turning up, and that's to be

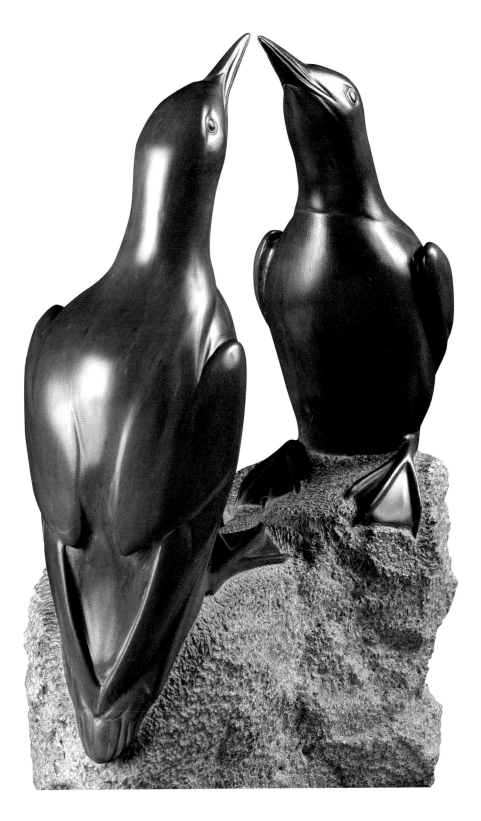

Courting Guillemots, 1985

Slate, 10 × 7 × 5 in.

Along the Sound, isolated islets and high, sandy banks provide nesting recesses for pigeon guillemots. About their nests they perform intricate courtship and greeting rituals in an avian pas de deux.

Guillemot Colony on Castle Rock, 1984
Ink drawing, 17 × 20 in.
In late winter pigeon guillemots gather to socialize,
court, and pair up for the forthcoming nesting season.
Male guillemots entice a female's interest with offerings
of small fish. These birds' activity, dramatic patterns of
black and white against the stubble of stone and sea-
weed, attract the artist's eye.

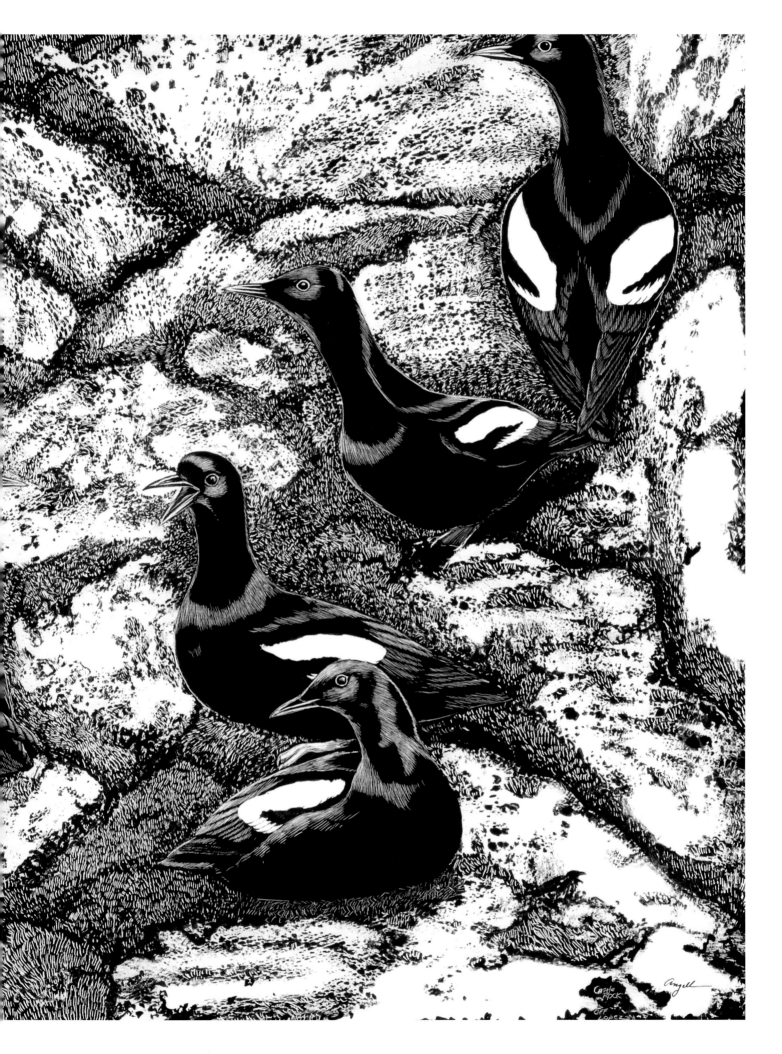

welcomed. Still, most of my memorable moments spent gathering impressions have been based on anticipation and planning. I went out with a search image in mind to discover something specific in the field, and I knew something of where, when, and how to seek it out. Once I found it, I would do my best to unobtrusively remain in its company.

Those times of summer and spring when we are most likely to be out and about in Puget Sound are not the most engaging to me. Late fall and winter, particularly along the shores, are really more rewarding times for observing the diversity of life that resides here. There are times I can feel surrounded by the vast fabric of interdependent species that form our region's living frame-work. I think particularly of what can be in the air on a winter's day. Flocks of waterfowl fly in to spread out over near shore waters, feeding in the thousands. Even greater numbers of shorebirds, including dunlin, sandpipers, and plover,

Plover Wing Stretching, 1980
Alabaster, 5 × 8 × 5 in.
The extended wing of a plover speaks eloquently of its embrace of the sky. I once read of a single bird of this species of plover that was banded on our East Coast and a few days later got caught in another bander's net on the coast of Africa, having traversed the entire Atlantic Ocean. Extending the wing in stone expands the aesthetic possibilities of the sculpture but tests the material's strength to hold over the reach of the form.

The Falcon's Flight, 1983
Serpentine, 12 × 14 × 4 in.
This slice of serpentine
felt like a discus in my
hands. What better goal
than to sculpturally "hurl"
it as a falcon in flight?

are coursing over in lowland fields and mudflats, often chased by the merlins, peregrines, and gyrfalcons that feed upon them.

When tides are very low, birds that forage in the shallows and at the waterline will be out some distance. But these times are my opportunity to examine a shoreline's floor, which is otherwise out of sight. Beds of eelgrass that have collapsed from lack of water to suspend the blades can be tread upon very carefully and only then parted gently to reveal some of the species in the community here. Exposed tide pools are aquatic windows into the life along our rocky shores. A glimpse into them reveals some of the specialized creatures that we never see when the tide is full. Conversely, at the higher tides the foraging shorebirds are tight against the shore, and when I can hunker down amid the drift logs and remain unseen, they often come to forage at my feet and even rest in my immediate company.

As compelling as a wild animal discovered in the field might be, averting your eyes to suggest you have no interest in it will sometimes keep you and your subject in close proximity. We're on their turf, and, as a rule, a wild creature should not be approached to the point that it becomes startled. Respect of its immediate hunting, feeding, or resting ground is critical for the animal's survival. Life in the wild doesn't allow for a lot of energy to be wasted by making retreats from intrusive bird watchers. Once in a while, however, I've gone ahead

Resting Shorebirds, 1997

Limestone, 5 × 18 × 12 in.

Migrating shorebirds settle in on the edge of a beach below the bluffs near Ebey's Landing on Whidbey Island. In the faint light they huddle together to weather the storm. It seems fitting that I fashion their forms in stone composed of the compressed shells of ancient crustaceans; in life, these brave travelers are sustained by the ancestors of these million-year-old fossils.

and reduced the distance between myself and an animal, believing that doing so discreetly would not disturb the object of my interest. Such was the case with a wintering snowy owl I once spied while driving a back road along the Samish Flats. Against the straw-colored fields the bird's bright white, blocky body stood out from where it perched on the edge of a berm above a small pond. This seemed the perfect opportunity to demonstrate to a friend my skills in approaching the owl by walking slowly but indirectly in its general direction. At the proper moment I intended to stop, turn, and take a picture.

Parking our car at a distance, I got out to shuffle into the chill wind, all the while keeping my eyes toward the ground and away from the owl. Every few steps I'd take a quick look to be sure of my direction. My glimpses suggested to me that the owl was scanning the surrounding fields, and it gave no impression that I was under scrutiny. When I had reduced my distance to twenty yards, I thought I'd put the finishing touches on my stalking demonstration by walking backwards a few feet before I turned to take my documenting photo. This last

decision was my undoing, however, as half a dozen steps later I felt the ground give way and I fell backward through the ice into a manure pond whose surface had been camouflaged by debris. In an instant, I was up to my shoulders in a ropy brew that left nothing to the imagination. The slippery edges of the pond made my exit even more ridiculous than my entry, and I could hear the laughter

Snowy Owl, 1998
Limestone, 22 × 12 × 10 in.
Female snowy owls are among the heaviest of their kind. Their contour feathers are underlined with a thick layer of down, giving them exceptional insulation against the severe cold of arctic winters. Many of the birds coming here seem fearless, having had little experience with humankind.

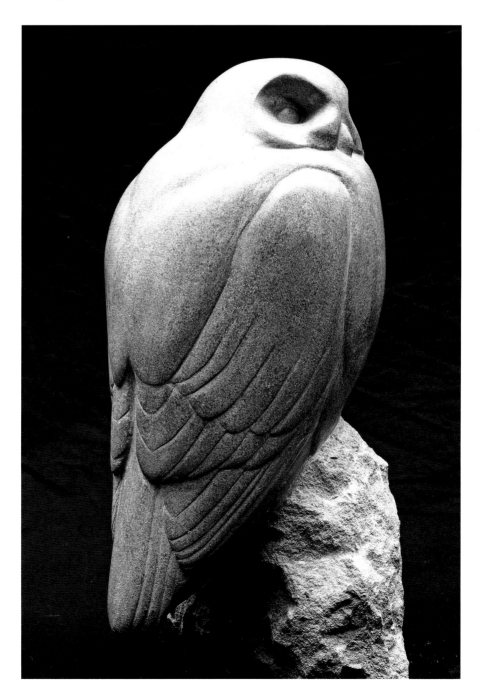

of my friend carried on the cold wind. The laughing stopped when I got into the car and turned on the heater as we headed home so I could get out of my clothing. Stirred up by the rush of hot air from the heater, the smell was overwhelming, but the discomfort of wet clothing becoming rigid when it's twenty degrees is even worse. As we drove away, I took a last look at the owl; it had remained on the berm. The bird seemed to be looking at something of interest in a nearby bed of grass.

The manure pond notwithstanding, as mentioned above, applying my senses to places in the Sound has been essential to what I do artistically. Recalling the cold edge of the winter's wind as I carve a falcon in flight, or smelling the damp iodine in the rush of surf over kelp when I fashion an otter with a fish all contribute to realizing the feeling of my subject.

Brooding Snowy Owl, 1978
River marble, 10 × 17 × 12 in.
I found this marble river stone on the banks of the Skagit River, and its centuries of tumbling in the waters had polished and shaped it to the point where there was little remaining for me to do but define the eyes of the owl.

Plover Bathing, 1979
River marble, 5 × 6 × 4 in.
Autumn sunlight beams down upon the beach's blend of grays and browns. Ahead of me, a single plover bathes where fresh water has gathered from a recent rain. The diminutive bird dips its wing into the pool, stirring up a mist radiant with sunshine.

Merganser at Water's Edge, 1978
Serpentine, 6 × 12 × 5 in.
An early work, this piece still holds much of what I feel when seeing these birds in our bays and lakes. Streamlined and graceful, these fish-catching ducks possess a liquid dimension—even at rest.

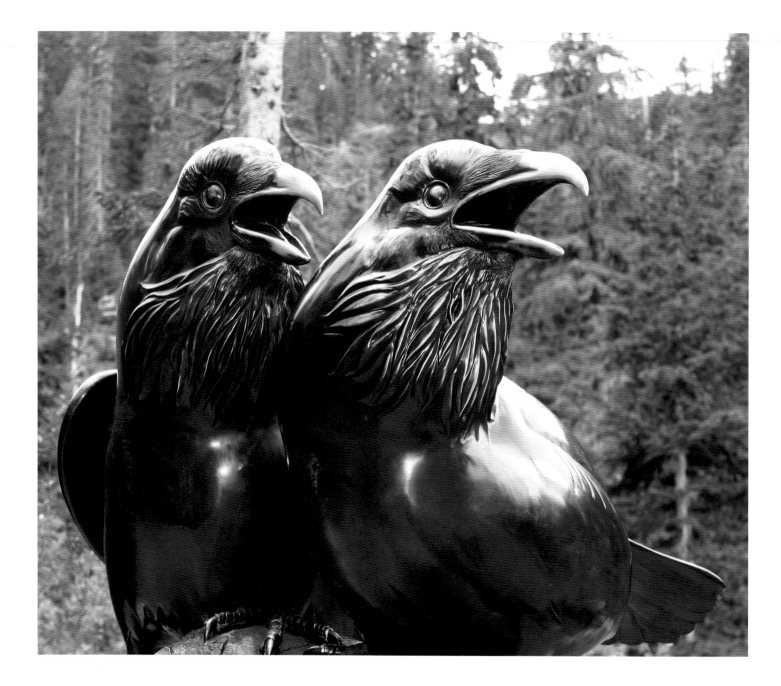

Emissaries, 2006
Bronze, 7 × 7 × 5 ft.
Throughout my life, ravens have served as the emissaries of wild places. They have reached mythic levels in human culture and seem to thrive where the lands and waters remain unsullied. In Puget Sound they still welcome us and take our measure.

AN AFTERWORD

I suggest that in saving Puget Sound, we save ourselves, and in restoring natural grace we earn inner grace.

—"OUR WHEEZING HEART: PUGET SOUND," SPEECH BY BILL DIETRICH AT PORT TOWNSEND MARINE CENTER, 2007

Inasmuch as my life has imbued me with no small measure of empathy for the wild creatures we share the region with, I'm compelled to relate some thoughts regarding the condition of our natural heritage. The "State of the Sound" report issued by the Department of Ecology in 2007 bluntly described our region's marine system as "one of decline, with continuing harms to the clean water, abundant habitat and intact natural processes that are the foundations of a healthy environment." The more recent disappearance and likely death of seven orcas from L pod suggests toxicity, bacteria, and a dwindling of the salmon population that these marine animals depend on. In other words, a good portion of the dynamic composition of life making up greater Puget Sound is in peril. The fact is, we've known this for at least a quarter of a century. In the early eighties we were reading reports of toxic embayments, habitat loss, diminishing fisheries, and threatened wildlife. There is no lack of knowledge about what we must address—only a lack of a consistent plan and the will to carry it out.

The degradation in the quality of marine environments is worldwide. In the February 15, 2008, issue of *Science*, a marine ecology study concluded that 96 percent of the world's oceans have been damaged by overfishing and pollution. Shoreline construction and development is destroying the ocean's biologically productive and cleansing vegetation. Our seas are absorbing ever-greater amounts of CO_2, and in doing so are becoming more acidic. This results in a die-off of plankton, those tiny plant and animal life forms that provide the foundation for the entire marine food chain.

And we're not being kind to our beaches either. Also in 2008, the Ocean Conservancy catalogued over 10,000 miles of littered shoreline worldwide. The amount of waste picked up on a single day in the United States alone was 390 million pounds, including metal cans, fish nets, lids, wrappers, plastics, tires, and glass. Of course, our beaches here in Puget Sound have their share of trash, but while picnickers and beachgoers contribute to the problem, much of it comes here on the currents and tides, having been dumped offshore or into mainland rivers. Chemicals from manufacturing and toxins leaching from debris move up the food chain to accumulate in the bodies of our marine birds, fish, and mammals, posing a serious threat to their welfare and, in turn, to ours as well. What garbage nightmare resides out of sight, below the water's surface, can only be imagined.

The more people, the greater potential for even bigger problems, and here on the Sound we have grown rapidly and suffered the consequences. Since I arrived here to attend college in 1958, we have doubled our population to more than four million people. We are projected to grow over the next few decades at a rate of 100,000 more souls each year—a number equivalent to the current size of the city of Everett.

In a ten-year span between 1990 and 2001, our sprawl across the landscape turned 190 square miles of service-providing forest into housing and shopping structures. Our settlements and enterprises use the Sound as a toilet and flush a billion gallons of wastewater and tons of chemical waste into it each year. To facilitate this, at least in part, we annually require 250 billion gallons of pure fresh water that might otherwise flow into the Sound and replenish and cleanse our estuaries. The Puget Sound Partnership reports in late 2008 that storm runoff puts 150,000 pounds of pollutants into Puget Sound every day.

The Sound's surface accommodates our commerce and recreation as well. In a recent year, 2,500 cargo ships visited our ports. Add another 200 cruise ships and perhaps 10,000 large and small recreational boats, and our 2,800-square-mile inland sea becomes a very busy place.

Given just this much activity, it's easy to imagine that life for some of our native species is increasingly difficult if not impossible. A recent piece by *Seattle Times* writer William Dietrich notes that since records were first kept on our wild salmon stocks in the Sound, we have lost an astonishing 92 percent of their original populations. That we have a sports fishery here at all is due largely to our heavily financed hatchery system. Other fish are suffering too. A report on several varieties of rockfish in the Sound indicates that some are on the verge of extinction. When I learned that some species may live for a hundred years, I wondered what environmental changes they might have witnessed within this sea.

River Spirit, 1982
Chlorite, 5 × 12 × 10 in.
Not unlike us, our abundant birds of the rivers, lakes, and sea are dependent on a steady supply of food resources. In this work I've sought to explore the hooded merganser's remarkable design of beak and body that so suits its fishing life.

It's axiomatic that as the fish populations decline, the animals dependent upon them will suffer. California and Steller sea lions, harbor seals, and orcas are all salmon consumers, and their presence here is determined by what they can find to sustain them. As the salmon's numbers have diminished, we've looked about for a convenient scapegoat, and the California sea lion fits the bill. Big and aggressive, they are hard to miss when they surface with a sockeye where the schools have concentrated to move through the Ballard Locks. When we compare the loss of fish due to our overfishing and habitat destruction, the sea lion's impact is miniscule.

My strongest concerns about wild nature in Puget Sound are regarding what I no longer witness here. Largely absent from both sides of the Sound are the flocks of brant calling softly to one another as they feed in the shallows just beyond the line of gentle surf. As our eelgrass beds have been dredged away, so have the populations of brant that fed here diminished in number. The eelgrass served as a nursery for herring, and as feeding and transition locations for young

salmon emerging from the rivers into their lives at sea. Fewer herring means fewer waterbirds that are sustained by them. I don't find large wintering flocks of Western grebes descending into embayments in the north Sound. This may signal that much of their food base here has been exhausted. Gone too are the rafts of common murres numbering in the hundreds that would routinely feed in the upwelling waters of channels between islands and out into the Strait of Juan de Fuca. The rent in the fabric of life here is widening.

Once a common winter sight just off our beaches, those muscular sea ducks, the scoters, are all but absent now. It has been more than a decade since I last witnessed male white-winged scoters perform their vigorous displays of flashing wings before prospective mates. Sighting a buoyant flock of migrant Bonaparte's gulls rising from the mudflats like great black-and-white butterflies is a rare moment as well. These once-vibrant voices have become whispers.

To be sure, there are examples of species recovery that provide us with hope and give us some direction in our efforts to restore and sustain our natural heritage. The ban in this country, implemented more than thirty years ago, on DDT and other toxic and persistent chemicals that entered the diets of animals (including humans) has been significant. Several species of birds have benefited, including the peregrine falcon and the bald eagle. Both species have returned to our region and increased their numbers. And no one visiting the Skagit delta in the fall and winter can help but be impressed by the healthy numbers of snow geese and tundra and trumpeter swans there. A half a century ago, swans were rarely seen here, and the snow geese were far fewer in number than they are today.

Even these encouraging signs require a closer look, however. When I think of the aforementioned decline of our native salmon and the degree to which our marine mammals require them as a food source, I wonder how long they can hold out on hatchery-reared fish and to what extent we are willing to feed them. The geese and the swans, recovered in part due to better management, are nevertheless subsidized by the agricultural crops they feed upon throughout the winter in the Skagit Valley. Their historical feeding places, the bull rush salt marshes, have been filled or are overgrown with invasive and inedible Spartina grass, and we are already finding that our agricultural requirements are in conflict with the wintering flocks of snow geese.

Beyond my musings here there exists far more detailed and expansive research in our Fish and Wildlife, Ecology, and Natural Resources departments. This information, as well as the data from Puget Sound Partnership, speaks to the condition of the region and its wild residents. Lynda Mapes of the *Seattle Times* has chronicled many of the changes that have occurred here, and while it is clear the Sound has lost diversity and vitality, one can conclude from her summations that the Sound still has a fighting chance for recovery. The mechanisms

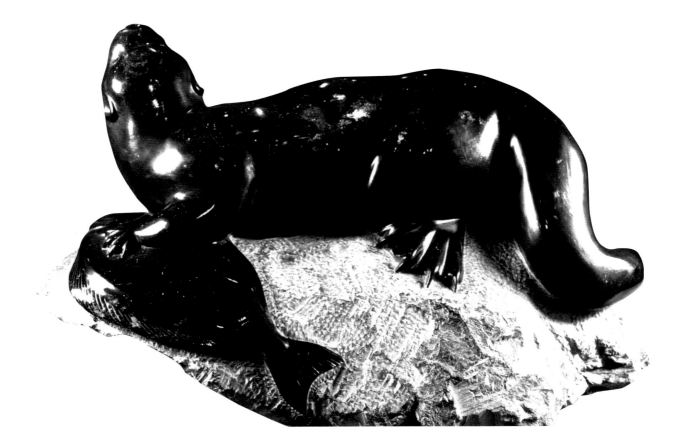

Sea Otter, 1978

Chlorite, 15 × 30 × 20 in.

The sea otter, while not resident in Puget Sound, is an example of a species' recovery in our larger marine system along the Pacific Coast. Over the past half century, these animals have recovered from near extinction, providing clues as to what is required to restore and sustain our natural heritage. This work has been in Seattle's Virginia Mason clinic for more than thirty years and has acquired a warm and glowing patina across its back and flanks that could have been applied only by the stroking of thousands of hands.

of sewage treatment, storm water management, and toxic cleanup are working. I can't help but believe, however, that much more of the same is needed if we are ever going to get abreast of the problems of the decline and degradation of the Sound's ecological integrity. There are abundant avenues by which we can respond individually and collectively, and that alone is reason for optimism for the future. Over the past several decades, ecological organizations have demonstrated remarkable leadership and taken action to protect remaining pristine habitat. Along with our state agencies responsible for resource conservation, The Nature Conservancy, the San Juan Preservation Trust, the Trust for Public

Land, and the Cascade Land Conservancy are a few organizations that with private and corporate donations have preserved and stewarded hundreds of square miles of some of the most pristine land and waters that are part of the heart and soul of Puget Sound. Educational and political action has been generated and sustained by People For Puget Sound, along with local chapters of the Audubon Society, the Sierra Club, and the Puget Sound Action Team.

While both have undergone a number of permutations, the Growth Management Act and the Puget Sound Partnership still provide a means of bringing together the public with all of the agencies, tribes, and businesses that have a stake in the health of Puget Sound. In these deliberating, consensus-building, and decision-making bodies we have the opportunity to collectively and unselfishly recommend and take immediate action on a plan for the future. It will be expensive, but it's difficult to imagine a price too high if it will restore and preserve Puget Sound.

There's no question in my mind that we have reached a point at which our population and expectations of Puget Sound are exhausting the very richness that brought us here in the first place. This region has been my wellspring as an artist and, as regionalist, almost the single source of my artistic ideas and motivation. And while I never set out to become a voice for my subjects, the possibility that I have done so is an extraordinary honor. Perhaps that is what art can become: an alliance where human emotion and expression combine with places and events that engage and nurture. What results may become a timeless testimony to those fundamental elements of nature that make our lives not just possible but worthwhile and fulfilling.

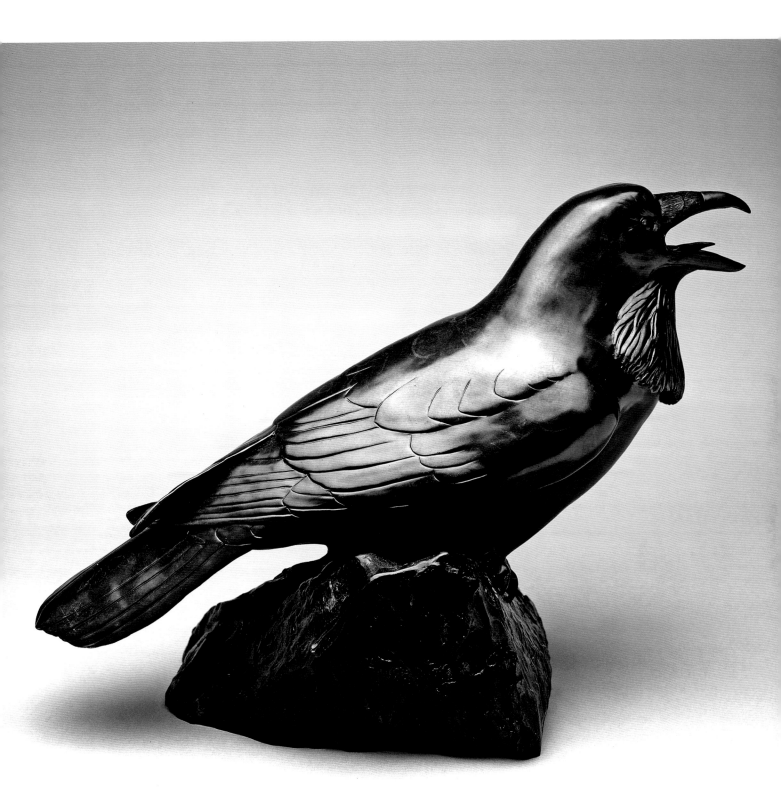

Raven Talk, 1990
Bronze, 12 × 18 × 6 in.
The Raven deserves the last word.

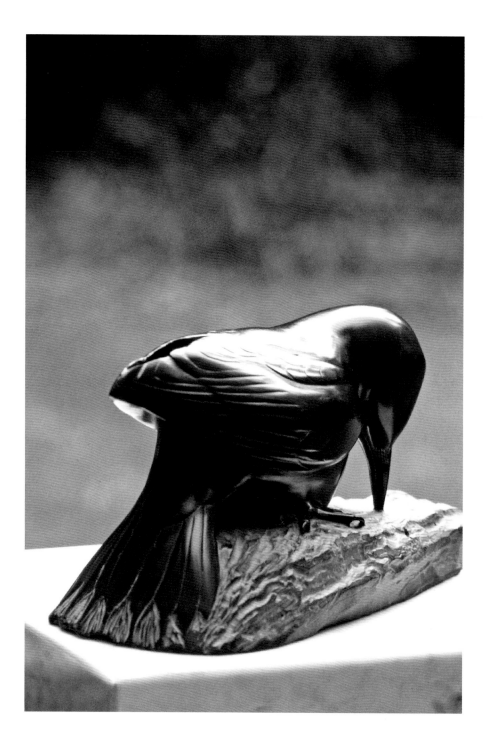

Working Bird/Flicker, 1993
Chlorite, 5 × 10 × 4 in.
Observing a region's wild heritage can become a portal through which we can discover and learn. The ubiquitous woodpecker engages our eye when it applies itself with vigorous industry as it feeds or chisels out its nest. Flickers are compelling to watch and apparently to possess as art as well. The day this piece was placed in my gallery in Seattle someone stole it. Have you seen it?

APPENDIX A

ARTISTS AND WRITERS
OF OTHER TIMES AND PLACES

By viewing Nature, Nature's handmaid, Art, makes mighty things from small beginnings grow.

—JOHN DRYDEN, "ANNUS MIRABILIS"

T here is a long and rich tradition of using art in describing our continent. As early as 1584, as Walter Raleigh scouted North American shores, expedition artist John White was rendering lovely images of the new species collected on the voyage. By the mid-eighteenth century, William and John Bartram combined their art and writings to document the southeastern portions of colonial America they explored and traveled through. Before the end of that century, the artists accompanying James Cook and George Vancouver would also provide images to record some of the natural history in the northwestern portions of our continent. In the first decade of the nineteenth century, the Corps of Discovery under Lewis and Clark had returned east from the Pacific with specimens and renderings suggesting the diversity of fauna and flora existing here in the Northwest, including descriptions of scores of condors feeding on spawned-out salmon along the banks of the Columbia River. In ship's logs, diaries, letters, and journals, information was combined with images to advance our understanding and appreciation of this new land.

Artistic documentation of nature in North America took a quantum leap in the early part of nineteenth century when first Alexander Wilson and then John James Audubon undertook the Herculean task of painting the birds of the continent. The work of these artist/naturalists would soon combine with that of landscape artists Thomas Cole, Albert Bierstadt, Frederick Church, John Frederick Kensett, and Thomas Moran to expand the public's consciousness of America's natural heritage as never before.

Throughout the twentieth and into the twenty-first century, art's role in

aesthetically restoring and sustaining our emotional contract with nature has not diminished. With paintings, prints, photographs, and motion pictures, we are given a front seat to witness the dynamics of nature. What is different, however, is that much of what we now see is no longer accessible firsthand to most of us. The exponential growth of human numbers and enterprises has overwhelmed many of our pristine ecosystems, and continues to do so today.

Here follows an eclectic selection of books that celebrate places and players in the theatre of nature. Over the years these books have been in my possession, I've gone to them again and again for information and inspiration. From the eye to the hand, both the writers and the artists have expressed what they see and feel. Their personal connections and convictions have clarified my own judgments on the importance of nature in my life. I list these as examples of how art serves us as a convenient and comfortable means to enter into some of the rich and subtle magic of what remains wild in Puget Sound.

Alexander Wilson: Naturalist and Pioneer, A Biography, by Robert Cantwell (Philadelphia: J. B. Lippincott Co., 1961). As a solitary artist, writer, and traveler through America's primal forests, Wilson has few rivals. In a relatively short period at the turn of the nineteenth century, he observed keenly, wrote expressively, and produced some of the first paintings of our continent's birds. Reading his accounts of the wild country of the East Coast and the South, wherein the now-extinct ivory-billed woodpecker and Carolina parakeet were common birds and passenger pigeons numbered in the billions, provides an exciting glimpse of what once was. Joining Wilson on his visits with the native people as he follows their paths along rivers and into woods is to travel back in time. In 1807, it was Wilson that Meriwether Lewis chose to illustrate the bird species he had returned with from his expedition to the West Coast. Only two years later, Thomas Jefferson would ask the artist to travel to the Natchez Trace in Tennessee to confirm circumstances surrounding Lewis's death by suicide.

Audubon's Birds of America, by Roger Peterson and Virginia Peterson (New York: Abbeville Publishing, 1981). Over the past decade, a flood of biographies on John James Audubon have been published. One hundred and fifty years after his death, Audubon's talent and storied life have again gained the public's admiration. Deservedly so. No artist/naturalist before or since has so tirelessly and vividly tied his creative record of nature to a place and time. This volume provides an accessible and large format for the reproductions of Audubon's famous Elephant Folio along with background on his paintings. Audubon's images include a look at a pristine and rural America where many species now gone or severely diminished in number were living in company with the people of the continent.

Audubon's journals, compiled as he developed a biography of each species

he painted, also provide intimate glimpses of early America, when wilderness was still our neighbor. To review his lavish paintings, while keeping in mind Audubon's narrative of his subject and the place in which he painted it, is a rare experience, and one begins to grasp the scale of wild country that has been lost or compromised in America. Audubon did not so much create a book of birds as, in Baron Cuvier's words, produce "the greatest monument ever erected by Man to Nature."

Thomas Moran, by Nancy Anderson (New Haven: Yale University Press, 1997). In the early 1870s, when Thomas Moran started painting in earnest, the continent was an open invitation to the creative mind. Along with Albert Bierstad, Thomas Cole, and others, Moran was among the most prolific painters of the open and rugged landscape. He concentrated his painterly energies on the Grand Canyon, the Snake River, and the canyons of the Yellowstone River. He created a record of place that inspired American thinking about the exceptional scale and beauty of the continent and stirred much of the initial political action that began a tradition of conservation and preservation of America's natural heritage. Indeed, his pictorial work strengthened the belief that the American character was linked inextricably to the majesty of the land.

Canoe Country, by Florence Page Jaques and Francis Lee Jaques (St. Paul: University of Minnesota Press, 1964). So romanced was I by the descriptions of the lake country conveyed by the author and her artist husband, I went to northern Minnesota largely on the basis of this book, one of several the Jaqueses wrote and illustrated together. The narrative and images convey directly what access to nature provides. In Florence's words, "Freedom surrounds us. We are finding more than peace here. This is an authentic and profound release from modern intricacies." My friendship with the Jaqueses was certainly based in part in our mutual belief that nature provides authentic and profound release.

The Singing Wilderness, by Sigurd F. Olson and illustrated by Francis Lee Jaques (New York: Alfred A. Knopf, 1956). The lakes and land of the Quetico Superior country of North America were an inexhaustible source of inspiration for the writer Sigurd Olson, who more than once combined his talents with those of artist Francis Lee Jaques to produce an exceptional portrait of place. I will always recall a day in the early 1960s when Olson, a devoted conservationist, was here in Seattle for a conference. I was driving near the University of Washington when I recognized him as he was entering a shop on University Avenue (his picture had appeared in the paper advertising his participation in the sessions held that day). Wanting to meet him and share my admiration for his work and that of Jaques, I looked for a place to park. By the time I was able to get to the shop, he had left and was nowhere in sight. I had lost my opportunity for a firsthand contact. He died the following year, but, like an esteemed friend, his books live on to inform and influence me.

Alaska's Copper River Delta, by Riki Ott (Seattle: University of Washington Press, 1998). Just to get a sense of what Puget Sound might once have been like, particularly where the Skagit River pours its waters into this inland sea, this fine book is worth one's study. Beyond that, it is an example of art and narrative combining to provide an intimate and comprehensive look at the Copper River Delta. In 1995, the Holland-based Artists for Nature Foundation joined with the city of Cordova, Alaska, to bring artists from throughout the world to interpret and document the exceptional abundance and natural diversity that still remained in the Copper River watershed and delta. Each of the twenty-three artists brought a unique skill and contrasting perspective to portray the complexity and beauty of life there. A passionate Russian painter, working rapidly and directly in watercolor along a stream bank, recorded the frantic moment of the sockeye's return. An English artist, engraving a wood block, captured the same experience in a more stylized and formal interpretation. While distilling the events differently, both renderings brought something fresh and singular to the subject.

Shorelands Winter Diary, by Charles Tunnicliffe (London: Clive Holloway Books, 1984). In a lively narrative and with bold ink scraperboard drawings, woodcuts, and paintings, Tunnicliffe records the subtle and dramatic events of the wild estuary where he and his wife live in the small village of Malltraeth along the coast of North Wales. Here are moments recorded in words, line, and color that wonderfully echo what remains to us in Puget Sound. Oystercatchers dance, harriers court, and falcons hunt in the artist's masterful portrayals of life along the shore. Few artists or writers have ever given a more complete expression and appreciation of a sacred place.

Bird Island: Pictures from a Shoal of Sand, by Lars Jonsson (London: Croom Helm, 1983). As Lars Jonsson put it, "The water-colours and the discourses in *Bird Island* emanate from an intoxicated inspiration; they are impressions from the island's short life during an intense summer." The dynamic nature of life at the edge of the sea is revealed through this artist's remarkable portraits of birds occupying a shoal of sand along the coast of Sweden. The similarities with the beaches bordering our Northwest waters and the species that occupy them provides one with insights on what may be occurring here, and offers an aesthetic invitation to take a look.

One Man's Island: A Naturalist's Year, by Keith Brockie (New York: Harper and Row, 1984). Keith Brockie's rugged individualism and consummate talent as a naturalist and painter was the combination needed to chronicle the wild nature on the Isle of May off the coast of Scotland. The artist responds to the emergent and varied life in the sea and upon the land over the course of a year. Brockie's distinctive point of view, expressed with patience and skill, brings you in an intimate and memorable way into the lives of the fish, plants, and animals

of the island. Those afield in the waters of Puget Sound will find similarities to our region in the island's weather variation and in the life that thrives there. Here again, art invites one to consider the deeper implications of places in nature.

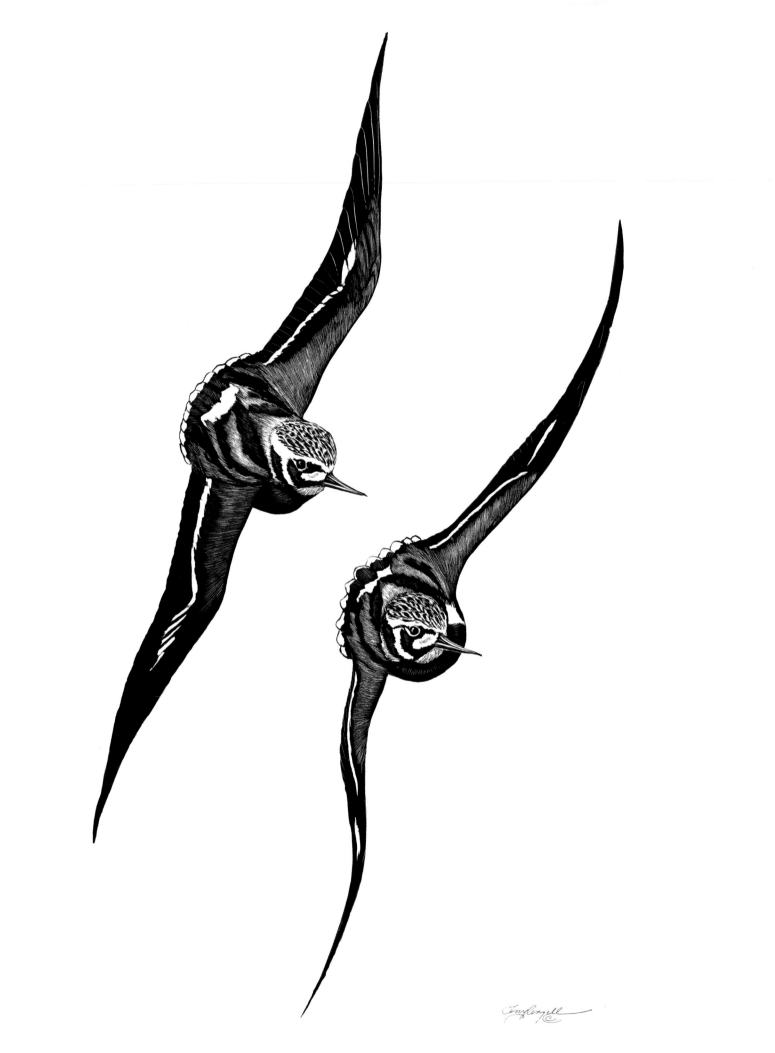